# Concerts of Antient Music

under the Patronage of Their Majesties
as Performed at the New Rooms, Hanover Square
1808

Elibron Classics
www.elibron.com

Elibron Classics series.

© 2007 Adamant Media Corporation.

ISBN 1-4021-5002-4 (paperback)
ISBN 1-4212-7751-4 (hardcover)

This Elibron Classics Replica Edition is an unabridged facsimile of the edition published in 1808 by W. Lee, London.

Elibron and Elibron Classics are trademarks of Adamant Media Corporation. All rights reserved.

This book is an accurate reproduction of the original. Any marks, names, colophons, imprints, logos or other symbols or identifiers that appear on or in this book, except for those of Adamant Media Corporation and BookSurge, LLC, are used only for historical reference and accuracy and are not meant to designate origin or imply any sponsorship by or license from any third party.

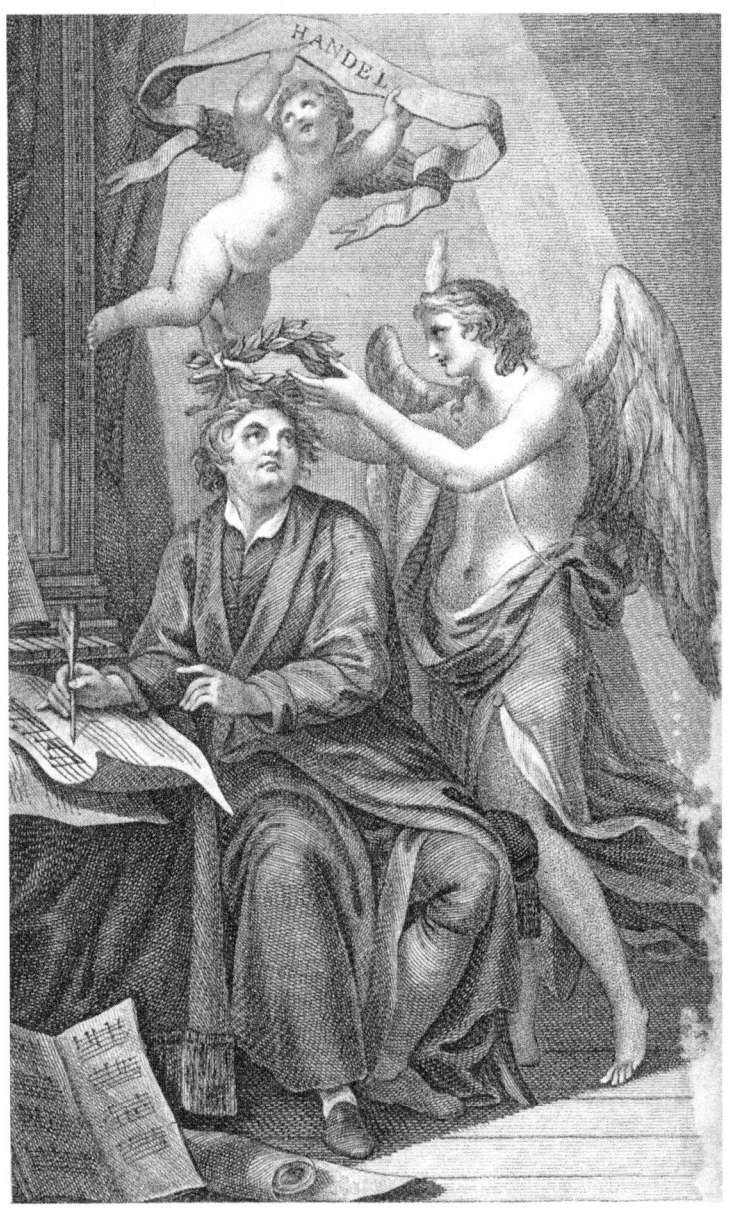

# CONCERTS

OF

# ANTIENT MUSIC,

UNDER THE PATRONAGE OF

## *THEIR MAJESTIES,*

AS PERFORMED AT THE

NEW ROOMS, HANOVER SQUARE.

---

1808.

---

*LONDON:*

PRINTED FOR W. LEE,

BY D. N. SHURY, 7, BERWICK STREET, SOHO.

# THE PERFORMANCES

## OF THE

# ANTIENT MUSIC,

FOR THE SEASON 1808.

PUBLISHED BY THE PERMISSION

OF THE

*Right Honourable Directors*

OF THE SAME,

ARE MOST HUMBLY PRESENTED TO THE SUBSCRIBERS

BY THEIR MUCH OBLIGED AND

MOST OBEDIENT HUMBLE SERVANT,

*W. LEE,*

*No. 18, Walnut-tree Walk,*

*Lambeth.*

# A LIST OF THE PERFORMERS.

## *VOCAL PERFORMERS.*

### PRINCIPAL SINGERS.

Mrs. BILLINGTON,

Mrs. VAUGHAN,

Mr. HARRISON, Mr. BELLAMY,

Mr. W. KNYVETT, Mr. SALE, Mr. SALE, jun.

Mr. GORE, Mr. ELLIOTT, Mr. GOSS,

and Mr. BARTLEMAN.

### CANTO CHORUS.

Eight Royal Chapel Boys
Four Abbey Boys
Four St. Paul's Boys
Master Hedgeley
Master Jones

### ALTO CHORUS.

Mr. Horsefall
Mr. Walker
Mr. Kendrick
Mr. Terry
Mr. Thomas
Mr. Jenks
Mr. Parr
Mr. Pheasant
Mr. Rogers
Mr. Hawes
Mr. Harris

| TENOR CHORUS. | BASS CHORUS. |
|---|---|
| Mr. Page | Mr. Fisher |
| Mr. James Page | Mr. Danby |
| Mr. Jones | Mr. Linton |
| Mr. Goodson | Mr. Galot |
| Mr. Willoughby | Mr. Warren |
| Mr. Everet | Mr. Weight |
| Mr. Randall | Mr. Renholds |
| Mr. Guichard | Mr. Tett |
| Mr. Dogherty | Mr. Ribbon |
| Mr. Griffiths | Mr. Elliott |
| Mr. Henshaw | Mr. Novello |
| Mr. Cooke | Mr. V. Novello |
| Mr. Kemm | Mr. Marquet |
| Mr. Watts | Mr. Fairclough |
|  | Mr. Clark |

# INSTRUMENTAL PERFORMERS.

Conductor......Mr. GREATOREX.
Leader.........Mr. CRAMER.

### VIOLINS.

Mr. Moralt
Mr. Hackwood
Mr. Rawlings, Jun.
Mr Mahon
Mr. W. Griesbach
Mr. C. Griesbach
Mr. F. Griesbach
Mr. W. Pick
Mr. Wagner
Mr. Storm
Mr. Holmes
Mr. Chabran
Mr. Volraht
Mr. Bohmer
Mr. Collard

### VIOLAS.

Mr. Mountain
Mr. Ashley
Mr. Sharp

Mr. Zink
Mr. Willcox
Mr. Reeve

### VIOLONCELLOS.

Mr. H. Griesbach
Mr. Eley
Mr. Moeller
Mr. Charles Lindley

### OBOES.

Mr. Kellner
Mr. Foster
Mr. Dickenson
Mr. Oliver

### BASSOONS.

Mr. Holmes
Mr. Kellner
Mr. Denman
Mr. Elliott

DOUBLE CHORUS.

Mr. Neibour
Mr. Boyce
Mr. Smart
Mr. Addisen

TRUMPETS.

Mr. Hyde
Mr. Cantelo

HORNS.

Mr. Leander

Mr. V. Leander
Mr. Kellner
Mr. G. Kellner

DRUMS.

Mr. Jenkinson

TROMBONES.

Mr. Marriotti
Mr. Zink
Mr. Moeller

AN

# ALPHABETICAL LIST

OF THE

## *SUBSCRIBERS*

TO THE

## Antient Music,

FOR THE PRESENT SEASON,

1808.

# A LIST, &c.

## UNDER THE PATRONAGE OF
## THEIR MAJESTIES.

### DIRECTORS.

| | |
|---|---|
| EARL OF CHESTERFIELD, | EARL FORTESCUE, |
| EARL OF DARTMOUTH, | EARL OF DARNLEY, |
| EARL OF UXBRIDGE, | EARL WILTON, |

LORD VIS. FITZWILLIAM.

### SUBSCRIBERS.

HIS ROYAL HIGHNESS THE PRINCE OF WALES,
HIS ROYAL HIGHNESS THE DUKE OF YORK,
HIS ROYAL HIGHNESS THE DUKE OF KENT, 2 Subs.
HIS ROYAL HIGHNESS THE DUKE OF CUMBERLAND,
HIS ROYAL HIGHNESS THE DUKE OF CAMBRIDGE,
HIS ROYAL HIGHNESS THE DUKE OF SUSSEX,     7

| | |
|---|---|
| Argyle, Duke of | Annesley, Lady Cath. |
| Amherst, R. H. D. Lady | Ashbrooke, Lord Vt. |
| Arden, Lord | Ashbrooke, Lady Vtss. |
| Arden, Lady | Alvanley, Lady |
| Arden, Honorable Miss | Abbot, Mrs |

Atherton, Mr. Henry
Atherton, Miss
Arnold, Dr.
Arnold, Mrs.
Adair, Mr.
Adair, Mrs.
Adams, Mr.
Adams, Mr. Charles
Adams, Mr. W. Dacre
Askew, Mr.
Askew, Mrs.
Askew, Miss D.
Angerstien, Mr. J. J.
Ainslie, Mr. Robert
Aldersey, Mrs.
Allen, Miss
Adams, Miss
Atkins, Mr.
Atkins, Mrs.                29

Blandford, Marquis of
Banbury, Earl of
Banbury, Countess of
Brooke, Lord W. D.
Boston, Lord
Bath & Wells, Ld. Bp. of
Burghersh, Lord
Bisshopp, Sir Cecil, Bart.
Bligh, Hon. General

Butler, Hon. Mrs.
Bromley, Lady
Burdett, Lady
Barry, Colonel
Barry, Lady Lucy
Browning, Rev. Dr.
Brown, Mr.
Brown. Mrs.
Brown, Miss
Brown, Mr. George
Balfour, Mrs.
Baldwyn, Mrs.
Bowles, Mr. George
Burton, Mr.
Burton, Mrs.
Barker, Mr. Raymond
Barker, Mrs. Raymond
Barker, Mrs.
Baring, Mr. Thomas
Baring, Mrs.
Bassett, Mr.
Blackburn, Mr. G.
Bevan, Miss
Bignell, Mr.
Bignell, Mrs.
Baker, Mr.
Baker, Mr. Charles
Brocus, Mrs.
Burney, Dr. Charles
Bate, Mr.
Bate, Mrs.
Bonar, Mr.

# SUBSCRIBERS.

Bonar, Mrs.
Bonar, Miss
Brent, Mr. D.
Barton, Mrs.
Bambridge, Miss
Batt, Mr.
Batt, Mrs.
Barne, Mr. Barne
Bonham, Mr. Henry
Bonham, Mrs. Henry
Bentham, Mr.
Bernard, Mr.
Bernard, Mrs.
Brickwood, Mr. John
Boddington, Mr. S.
Batty, Mr. Charles
Batty, Mrs. Charles
Bell, Mr.
Bell, Mrs.
Bell, Mr. John
Bampfylde, Sir Charles
Balfour, General Nesbit
Bourne, Mrs. Sturges
Bruce, Mr. Crawford
Bruce, Mrs. Crawford
Bruce, Miss
Bradberry, Mr.
Buller, Mr.
Buller, Miss
Buller, Miss
Brownrigg, General
Brownrigg, Miss
Baker, Mrs.

Canterbury, L. A. B. of
Curzon, Lord Viscount
Cave, Lady
Cotterell, Sir Stephen
Chester, Dean of
Cornwallis, Hon. Mrs.
Cornwallis, Miss
Currie, Mr. John
Currie, Mrs. Isaac
Currie, Mrs.
Currie, Miss Mary Ann
Children, Mr.
Canning, Mr. H.
Connop, Mr.
Connop, Mrs.
Connop, Miss
Courtenay, Mr. Tho.
Courtney, Rev. Mr.
Champion, Mr. B.
Champion, Miss
Cary, Miss
Clarke, Mrs.
Cannon, Rev. Edward
Calvert, Mr. Charles
Cooper, Lieut. Col.

## SUBSCRIBERS.

Cox, Mr. S. C.
Chamier, Mr.
Cator, Mr. John
Cator, Mrs.
Cockburn, Capt.
Clowes, Miss
Cholmley, Mr.    32

Dorset, Duchess of
Dartmouth, Countess of
Darnley, Countess of
Dudley & Ward, Ld. V.
Dudley & Ward, Ly. V.
Dunstanville, Lord De
Dacre, Dowager Lady
Dundas, Gen. Sir David
Dundas, Lady
Dufferin, Lady
Davis, Rev. Dr.
Dorrien, Mr. T.
Dorrien, Mrs. T.
Dorrien, Miss
Drummond, Mr. C.
Drummond, Mrs. C.
Dampier, Mrs.
Deverell, Mr.    18

Effingham, Earl of
Errol, Dowager, Lady
Ellenborough, Lady
Eden, Sir Frederick
Eden, Miss
Eyton, Mr.
Egerton, Miss
Egerton, Mr.
Egerton, Mrs.
Egerton, Mr. Wilbram
Egerton, Mrs. Wilbram
Evans, Mr.
Evans, Mrs.    13

Fermor, Hon. Col.
Fouquire, Mrs.
Forster, Mr. E. Junior
Forster, Mrs. E.
Foster, Col.
Free, Mr.
Free, Mrs.
Fletcher, Mr. Joseph
Fletcher, Miss
Fothergill, Miss
Fitzherbert, Mr. T.

## SUBSCRIBERS.

Franklin, Mr.
Franklin, Mr. W.
Franklin, Miss
Fraser, Miss Makenzie 15

Grosvenor, Countess of
Grey, Earl
Grey, Lord
Grey, Lady
Grosvenor, Hon. D.
Grosvenor, Hon. Gen.
Gosford, Earl of
Gosford, Countess of
Guildford, Countess of
Glynne, Lady
Gage, Sir Thos. Bart.
Gardiner, Sir J. W. Bart.
Graham, Mr. Baron
Graham, Lady
Gibbs, Lady
Gibbs, Miss
Grimstone, Hon. Mr.
Grimstone, Lady C.
Grant, Mr. Hy.
Grant, Mrs. Hy.
Grant, Miss
Gosling, Mr. F.
Gosling, Mrs. F.
Gosling, Miss
Gaussen, Mr.
Gaussen, Miss

Gillon, Mr John
Gwatkin, Mr.
Gwatkin, Mrs.
Gregg, Mr. F.
Gregg, Mrs. F.
Grigby, Mr.
Greville, Rev. James 33

Hampden, Lord Vis.
Harley, Lady Jane Eliz.
Hudson, Lady
Hudson, Miss
Harris, Lady Catherine
Hastings, Lady
Hall, Mr.
Hall, Mrs.
Howe, Lieut. Col.
Heathcote, Mrs.
Heathcote, Mr.
Heathcote, Miss
Hoare, Mr. H.
Hoare, Mrs. H.
Hoare, Miss
Heaviside, Mr.
Holford, Mr. Robert
Houblon, Mrs.
Houblon, Miss L.
Hatsell, Mr.
Hatsell, Miss

## SUBSCRIBERS.

Harthall, Mr. Van
Hutton, Mrs
Holloway, Mr Thomas
Hanbury, Mrs.
Hanbury, Mrs. F.
Hammersley, Mr.
Hughes, Mr.
Hughes, Mrs.
Hawkins, Sir Chris. Bt.
Hallifax, Mr. Saville
Hatton, Mr. E. F.
Hobson, Mr.
Hume, Mrs.
Hawkins, Mr. Bolton 35

Jones, Mrs.
Jones, Mr. Walter
Jones, Mrs. Walter 18

Kinnaird, Lord
Kenyon, Lord
Kenyon, Lady
Knox, Hon. Thomas
Keysall, Mr.
Knightley, Mrs.
King, Rev. C.
Key, Mr. H. G.   8

Jersey, Countess of
Ibbetson, Lady
Ibbetson, Miss
Jones, Lady
Jones, Rt. Hon. T.
Jones, Rev. Dr.
Jones, Mrs.
Jones, General
Jones, Mrs.
Jones, Mr. William
Ireland, Rev. Dr.
Joddrell, Mr. H.
Joddrell, Mrs.
Jeffery, Mr. John
Johnson, Mr. C.

Longford, Lord
Long, Lady, C. T.
Lucas, Lady
Langham, Sir William
Leighton, Mrs.
Leycester, Mr. Hugh
Lane, Mr.
Long, Mr.
Long, Mrs.
Lawrell, Mrs.
Ley, Mr.
Lang, Mr.
Lang, Mrs.
Latham, Mr. T. Davenport

Laham, Mrs. T. Davenport
Lushington, Mr. S. R.
Lemon, Col.
Lambert, Mr. C.
Lawrence, Mr. T.
Linley, Mr.     20

Mansfield, Earl of
Mansfield, Countess of
Mulgrave, Lady
Mount Norris, Earl of
Mount Norris, Countess of
Montague, Lady E.
Macdonald, Lord
Macdonald, Hon. Gen.
Mordaunt, General
Milward, Mrs.
Meyrick, Mr.
Meyrick, Mrs.
Morton, Mrs.
Mount, Mr.
Mount, Mrs.
Mount, Miss
Mount, Miss E.
Marsh, Mr.
Marsh, Miss
Marsh, Miss Ann

Mathew, Mrs. Brownlow
Musgrave, Mr.
Musgrave, Mrs.
Mathias, Mr. T. J.
Marsden, Mr.
Marsden, Mrs.
Maloni, Miss
Montgomery, Miss
Mills, Mr. C.
Mills, Mrs. C.
Mills, Mr.
Madocks, Miss     32

Northwick, Lord
Nugent, Admiral
Neave, Lady
Neave, Mrs. John
Neave, Mr. R.
North, Miss L.
North, Mr. Dudley
Nixon, Mr. John
Nesbet, Mr. John
Nott, Rev. Dr
Nott, Mrs.     11

## SUBSCRIBERS.

Oxford, Earl of
Oxford, Countess of
Oglander, Mrs.
Oram, Mr.
O'Hara, Mr. H.           5

Pagett, Hon. Captain
Paget, Lord
Pagett, Hon. Berkly
Phipps, Hon. Maj. Gen.
Preston, Lady
Pusey, Hon. Mr.
Peat, Rev. Sir Robert
Pepys, Sir Lucas
Pepys, Sir Weller
Prime, Mr.
Prime, Mrs.
Prime, Mr. Richard
Prime, Miss
Prime, Miss E.
Prime, Miss F.
Powel, Mr. John Clerk
Palmer, Mr. T.
Penny, Mrs.
Penny, Miss
Preston, Mrs.
Pearse, Mr.
Pearse, Mr. John
Pearse, Mrs. John

Pearse, Mr. Jun.
Pearse, Mr. N.
Pearse, Mrs. N.
Porcher, Mr.
Porcher, Mrs.
Parsons, Mrs.
Pelly, Mr.
Pelly, Mrs.
Pieschell, Mr. C.
Pechelle, Miss Ann
Pigou, Mr. William
Pigou, Mrs. William
Pitt, Mr. Thomas
Pitt, Miss
Pole, Mr. C.
Pole, Mrs. C.
Pott, Mr.
Price, Dr.
Price, Mrs.
Parnther, Mr.
Parnther, Mrs.
Pattison, Mr. James
Purling, Mr. G.
Parker, Mr. Lister
Pote, Mr.
Pilgrim, Mr. C.
Peters, Mrs.           49

## SUBSCRIBERS.

Radnor, Earl of
Ranelagh, Viscount
Reay, Lord
Reade, Dowager Lady
Read, Lieut. General
Raikes, Mr.
Raikes, Mrs.
Raikes, Miss
Raikes, Miss H.
Raikes, Mr. G.
Rolle, Miss M.
Rowe, Mrs.
Roe, Mr.
Roe, Miss
Robinson, Rev. Mr.
Robarts, Mr.
Rogers, Sir John
Rogers, Mr. Henry
Rogers, Mr. Samuel
Rebow, Col. Slater
Rebow, Mrs. Slater
Ryder, Mr.
Richards, Mr. J. B.
Raine, Dr.
Raine, Miss
Reeve, Mr. S.
Reeve, Miss
Rucker, Mr.
Rucker, Mrs
Ross, Mrs.

Rattray, Mrs.
Roworth, Mr.    32

Spencer, Earl
St. Vincent, Countess of
Selkirk, Earl of
Selkirk, Countess of
Sunderlin, Lord
Sommerville, Lord
Stephens, Sir Philip, Bt.
Shelley, Sir John, Bt.
Sykes, Sir Mark
Smith, Sir Drummond, Bt.
Smith, Lady
Smith, Sir John
Smith, Mr. G.
Smith, Mrs. G.
Smith, Mr. C.
Smith, Mrs. C.
Smith, Miss Emily
Smith, Mr. Joseph
Smith, Mr. James
Smith, Mrs. James
Smith, Mr. W.
Smith, Mrs. W.
Smith, Mr. Robert
Smith, Mr. Thomas
Stainforth, Mr.
Stainforth, Mrs.
Simpson, Mrs.

## SUBSCRIBERS.

Sharp, Mr. R.
Scott, Mr. Claude
Scott, Mrs. Claude
Simeon, Mr.
Simeon, Mrs.
Simeon, Miss
Selwyn, Mr. W.
Selwyn, Miss.
Selwyn, Miss F.
Shum, Mrs.
Shum, Miss
Salmon, Miss
Sloan, Mr. Hans
Salt, Mr.
Savage, Rev. Mr.
Savage, Mrs.
Simms, Dr.
Sealy, Miss
Shard, Mrs. S.
Shipley, Mrs. C. L.
Sloper, Miss
Stanhope, Mr. Arthur
Shuttleworth, Miss E.
Snodgrass, Mr.
Steinbergens, Miss
Stables, Mrs.
Stables, Miss F.
Stevens, Mr.  55

Talbot, Sir C.
Townshend, Hon. Miss
Trail, Mr. Henry
Trail, Mrs. Henry
Templeman, Mr. G.
Turner, Mr. John
Turner, Mrs.
Taylor, Rev. George
Trant, Mr.
Tippet, Mrs.
Tippet, Miss
Thornton, Mr.
Thornton, Mrs.
Thornton, Miss
Thornton, Miss
Trewelyan, Mr.  16

Uxbridge, Countess of
Upton, Hon. Miss
Udny, Captain  3

Vernon, Lord
Vernon, Lady Ann
Vernon, Mr.
Vere, Mrs.
Voss, Mr.
Voss, Mrs.  6

# SUBSCRIBERS.

Winchester, Ld. Bisp. of
Winterton, Countess of
Whitworth, Lord
Wodehouse, Lord
Windsor, Rev. Dean of
Warrender, Sir George
Wollaston, Rev. Mr.
Wollaston, Miss Ann
Wollaston, Mr. Charlton
Wollaston, Dr.
Willis, Mrs.
Willis, Miss Amelia
Wynn, Miss Williams
West, Mr. Temple
Weyland, Mr.
Weyland, Miss M.
Weyland, Miss L. C.
Webber, Mrs.
Webber, Miss
Wheeler, Rev. Mr.
Wigram, Lady
Wigram, Mr. J.
Wigram, Mr. W.
Wigram, Mr.
Wigram, Miss
Wigram, Miss E.
Woodford, Mr.
Wigan, Rev. Mr.

Warburton, Miss
Winter, Mr.
Winter, Miss
Winter, Miss E.
Winter, Miss F.
Woodgate, Mr. H.
Willink, Mr. D.
Willink, Mrs. D.
Willink, Mr. J. A.
Wishaw, Mr.
Wegg, Mr.
Wegg, Mrs.
Willet, Mr.
Willet, Mrs.
Willet, Mr. H.
Woodcock, Mr. John
Whitelock, Miss
Walton, Mrs.
Wilson, Miss
Watts, Mr. D. P.
Watts, Mrs.
Williams, Mr. Owen
Williams, Mrs. Owen
Williams, Mr. Robert
Williams, Mrs. R.       53

York, L. A. B. of       1

## NUMBER OF SUBSCRIBERS.

Royal Subscription.................... 7
Subscribers......................... 569
                              Total....576

(No. I.)

UNDER THE DIRECTION OF

## THE EARL OF DARTMOUTH.

# CONCERT OF ANCIENT MUSIC,

WEDNESDAY, FEBRUARY 10, 1808.

### ACT I.

Coronation Anthem.　Zadock the Priest.　　*Handel.*
Trio.　Non è amor.　　(*Alcina.*)　　*Handel.*
Chorus.　Gloria in excelsis.　　　*Pergolesi.*
Overture. }
Recit and Chorus. From } (*Dryden's Ode.*)　*Handel.*
　harmony. }
Song.　Confusa, abbandonata.　　　*Bach.*
Chorus.　See the proud chief. }
Song.　Tears, such as tender. } (*Deborah.*) *Handel.*
Double Chorus.　The Lord. (*Is. in Egypt.*) *Handel.*

### ACT II.

Overture.　　(*Pharamond.*)　　*Handel.*
Song.　Rendi il sereno.　(*Sosarmes.*)　*Handel.*
Sestetto.　In braccio a te.　(*Justin.*)　*Handel.*
Song.　What though I trace.　(*Solomon.*)　*Handel.*
Concerto 9th.　　　　*Corelli.*
Song.　Lord, to thee.　(*Theodora.*)　*Handel.*
Quart. & Chorus.　Then round.　(*Samson.*) *Handel.*
Recit.　Ye sacred priests. }
Song.　Farewel, ye limpid. } (*Jephthah.*) *Handel.*
Grand Chorus.　Hallelujah.　(*Messiah.*)　*Handel.*

B

## ACT I.

### ANTHEM. *Handel.*

Zadock the priest, and Nathan the prophet, anointed Solomon King: and all the people rejoiced and said, God save the King—long live the King—may the King live for ever. Hallelujah. Amen.

### TRIO. Mrs. BILLINGTON, Mr. HARRISON, and Mr. BARTLEMAN.

(ALCINA.) *Handel.*

Non è amor, nè gelosia;
E pietà; è desio che lieta godi.
Non t'offendo, non t'inganno,
Cruda donna rio tiranno,
Non voglio da voi mercè:

Solo affanni, e solo pene,
Premio fian di vostra fè.
Che ascose frodi, iniqua menti!
Non sperar da noi mercè,
Caro sposo, solo gioia, e solo bene,
Premio fian di nostra fè.

Che fallaci, infido, accenti!
Indegna taci,
Non sperar da noi mercè.
Anima mia, solo gioia e solo bene.
Premio fian di nostra fè.

### CHORUS. *Pergolesi*

Gloria in excelsis; Deo gloria
Et in terra pax.
Hominibus bonæ voluntatis.

### RECIT. Mr. HARRISON.
(Dryden's Ode.) *Handel.*

From harmony, from heav'nly harmony,
This universal frame began.

### RECIT. acc.

When Nature, underneath a heap
    Of jarring atoms lay,
  And could not heave her head.
The tuneful voice was heard from high,
    Arise, ye more than dead!
Then cold, and hot, and moist, and dry,
In order to their stations leap,
    And Music's power obey.

### CHORUS.

From harmony, from heav'nly harmony,
    This universal frame began;
Thro' all the compass of the notes it ran,
    The diapason closing full in man.

---

### SONG. Mrs. BILLINGTON. *Bach.*

Confusa, abbandonata,
  A mille affanni in seno;
Dalla mia sorte irata,
  Mi sento trasportar.
Dalla crudel mia sorte
  So disprezzar lo sdegno:
Da servitù la morte,
  Non mi farà tremar.      *Da Capo.*

CHORUS.      (DEBORAH.)      *Handel.*

See the proud chief advances now
With sullen march and gloomy brow;
Jacob arise, assert thy God,
And scorn Oppression's iron rod.

SONG. Mr. BARTLEMAN.

Tears, such as tender fathers shed,
    Warm from my aged eyes descend,
For joy, to think, when I am dead,
    My son shall have mankind his friend.

CHORUS.      (ISRAEL IN EGYPT.)      *Handel.*

The Lord shall reign for ever and ever.

RECIT. Mr. HARRISON.

For the horse of Pharoah went in with his chariots, and with his horsemen into the sea. And the Lord brought again the waters of the sea upon them, but the children of Israel went on dry land in the midst of the sea.

## CHORUS.

The Lord shall reign for ever and ever.

## RECIT.  Mr. HARRISON.

And Miriam, the prophetess, the sister of Aaron, took a timbrel in her hand: and all the women went out after her with timbrels and with dances: and Miriam answer'd them.

## AIR.  Mrs. BILLINGTON.

Sing ye to the Lord, for he hath triumphed gloriously:
The horse and his rider hath he thrown into the sea.

## CHORUS.

The Lord shall reign for ever and ever.

## DOUBLE CHORUS.

I will sing unto the Lord, for he hath triumphed gloriously:
The horse and his rider hath he thrown into the sea.

END OF THE FIRST ACT.

## ACT II.

SONG. Mr. HARRISON. (Sosarmes.) *Handel.*

Rendi il sereno al ciglio,
　Madre, non pianger più,
Temer d'alcun periglio,
Oggi come puoi tu ? *Da Capo.*

SESTETTO.

Mrs. BILLINGTON, Mrs. VAUGHAN,
Messrs. GOSS, Wm. KNYVETT, HARRISON,
and BARTLEMAN.
(Justin.) *Handel.*

In braccio a te la calma
Del cor, dell' sen, dell' alma,
Mio caro al fin godrò.

In braccio a te mia vita,
Già lieta amor m'invita,
   Chi più bel dì mirò?
Mi rese il tuo valore
M'accumolò l'onore
   Tutta { la pace al cor. }
          { la gloria al cor. }
Rinasce il secol d'or.
Siam lieti in questo giorno
E sparga il suon d'intorno,
Che doppo oscuro velo
Resplende chiaro il Cielo
E dà la pace al cor.
Cessate le procelle,
Amiche abbiam le stelle:
Del fato abbiam la palma:
Godiam felice calma,
Rinasce il secol d'or.

SONG. Mrs. VAUGHAN. (SOLOMON.) *Handel.*

What though I trace each herb and flow'r
   That drinks the morning dew;
Did I not own Jehovah's pow'r,
   How vain were all I knew!

SONG. Mr. BARTLEMAN. (THEODORA.) *Handel.*

 Lord to Thee, each night and day,
 Strong in hope, we sing and pray;
 Though convulsive rocks the ground,
 And thy thunders roll around,
 Still to Thee, each night and day,
 Strong in hope, we sing and pray.  *Da Capo.*

QUARTET. Mrs. VAUGHAN,
Messrs. HARRISON, W. KNYVETT, and
BARTLEMAN, and CHORUS.
(SAMSON.)  *Handel.*

 Then round about the starry throne
 Of him who ever rules alone,
 Your heav'nly-guided soul shall climb:
 Of all this earthly grossness quit,
 And triumph over Death, and thee, O Time.

RECIT. Mrs. BILLINGTON. (JEPHTHAH.) *Handel.*

Ye sacred priests, whose hands ne'er yet were stain'd
With human blood, why are ye thus afraid
To execute my father's will? The call
Of Heaven, with humble resignation I obey.

## SONG.

Farewel, ye limpid springs and floods,
Ye flow'ry meads, and mazy woods!
Farewel, thou busy world, where reign
Short hours of joy and years of pain!
    Brighter scenes I seek above,
    In the realms of peace and love.

---

GRAND CHORUS.     (MESSIAH.)     *Handel.*

Hallelujah! for the Lord God omnipotent reigneth. The kingdom of this world is become the kingdom of our Lord, and of his Christ; and he shall reign for ever and ever, King of kings, and Lord of lords.

                           HALLELUJAH.

**END OF THE FIRST CONCERT.**

(No. 2.)

UNDER THE DIRECTION OF
## *THE EARL OF UXBRIDGE,*
## *FOR THE EARL OF CHESTERFIELD.*

# CONCERT OF ANTIENT MUSIC,
### THURSDAY, FEBRUARY 18, 1808.

## ACT I.

| | | |
|---|---|---|
| Overture. | (*Esther.*) | *Handel.* |
| Double Chorus. | Your harps. (*Solomon.*) | *Handel.* |
| Scene. | (*From Tyrannic Love.*) | *Purcell.* |
| Chorus. | He rebuked. (*Is. in Egypt.*) | *Handel.* |
| Quintetto. | Doni pace. (*Flavius.*) | *Handel.* |
| Concerto 4th. | (*From his Solos.*) | *Geminiani.* |

Recit. acc. Rejoice my. } (*Belshazzar.*) *Handel.*
Chorus. Sing, O ye. }

Song. Sconsolata andai.      *Bach.*

Recit. 'Tis well; six times. }
March.                        } (*Joshua.*) *Handel.*
Air and Chorus. Glory to. }

## ACT II.

| | | |
|---|---|---|
| Concerto 2nd. | (*Oboe.*) | *Handel.* |
| Chorus. | The many. (*Alexander's Feast.*) | *Handel.* |
| Song. | Odi grand' ombra. | *De Majo.* |
| Madrigal. | In the merry month. | *Dr. Cooke.* |
| Anthem. | Sing unto God. | *Dr. Croft.* |
| Song. | O Lord have mercy. | *Pergolesi.* |
| Concerto. 1st. | | *Corelli.* |

Recit. O worse than death. } (*Theodora.*) *Handel.*
Song. Angels ever bright. }

Chorus. Fix'd in his. (*Samson.*)    *Handel.*

## ACT I.

DOUBLE CHORUS. (Solomon.) *Handel.*

 Your harps and cymbals sound
 To great Jehovah's praise;
 Unto the Lord of Hosts
 Your willing voices raise.

SCENE from TYRANNIC LOVE. *Purcell.*

The Solo Parts by Mrs. VAUGHAN,
Mess. HARRISON, W. KNYVETT, and
BARTLEMAN.

Hark! my Daridcar! hark! we're call'd below;
 Let us go to relieve the care
 Of longing lovers in despair;
 Merry we sail from the east,
 Half tippled at the rainbow feast;

In the bright moonshine, while the winds whistle loud,
Tivy, tivy, we mount, we fly, all racking along in a
    downy white cloud;
And lest our leap from the sky should prove too far,
We'll slide on the back of a new-fallen star.
But now the sun's down, and the element's red,
The spirits of fire against us make head;
    They muster like gnats in the air:
    Alas! I must leave thee, my fair,
    And to my light horsemen repair.
Oh! stay, for you need not to fear 'em to night;
The wind is for us, and blows full in their sight,
    And o'er the wide ocean we fight.
Like leaves in the autumn our foes will fall down,
    And hiss in the water and drown.
But their men lie securely intrench'd in a cloud,
And a trumpeter hornet to battle sounds loud;
    All mortals that spy
    How we tilt in the sky,
    With wonder will gaze,
And fear such events as will ne'er come to pass.
Stay you to perform what the fates would have
    done:—
Then call me again when the battle is won.

## QUARTET. and CHORUS.

    So ready and quick is a spirit of air
    To pity the lover and succour the fair,
    That silent and swift the little soft god
    Is here with a wish, and gone with a nod.

CHORUS.   (ISRAEL IN EGYPT.)   *Handel.*

He rebuked the Red Sea, and it was dried up.

He led them through the deep, as through a wilderness.

But the waters overwhelmed their enemies; there was not one of them left.

## QUINTETTO.
Mrs. BILLINGTON, Mrs. VAUGHAN,
Messrs. HARRISON, W. KNYVETT,
and BARTLEMAN.
(FLAVIUS.)   *Handel.*

Doni Pace ad ogni core
Quella gioia che sparì
E cessato or il dolore
Goda ogn' alma in questo dì.   *Da Capo.*

RECIT.   Mr. BARTLEMAN.
(BELSHAZZAR.)   *Handel.*

Rejoice, my countrymen; the time draws near,
The long expected time herein foretold:

Seek now the Lord your God with all your heart,
And you shall surely find him : He shall turn
Your long captivity : He shall gather you
From all the nations whither you are driven,
And to your native land in peace restore you.

### RECIT.

For long ago, whole ages, ere this Cyrus yet was born,
Or thought of, Great Jehovah, by his prophet,
In words of comfort to his captive people
Foretold, and call'd by name the wond'rous man.

### RECIT. acc.

Thus saith the Lord to Cyrus his anointed,
Whose right hand I have holden, to subdue
Nations before him : I will go before thee,
To loose the strong-knit loins of mighty Kings,
Make straight the crooked places, break in pieces
The gates of solid brass, and cut in sunder
The bars of iron. For my servant's sake,
Israel my chosen, though thou hast not known me.
I have surnamed thee : I have girded thee :
That from the rising to the setting sun
The nations may confess I am the Lord,
There is none else, there is no God besides me,
Thou shalt perform my pleasure to Jerusalem,
Saying, " Thou shalt be built;" and to the Temple,
" Thy raz'd foundation shall again be laid."

## CHORUS.

Sing, O ye heavens! for the Lord hath done it:
Earth, from thy centre shout:
Break forth ye mountains, into songs of joy:
O forest, and each tree therein:
Jehovah hath redeemed Jacob,
And glorify'd himself in Israel.
      HALLELUJAH. Amen.

### SONG. Mrs. BILLINGTON. *Bach.*

 Sconsolata andai vagando
 Fra le affanni e fra le pene,
 Ma vicina al caro bene
 Or ritorno a respirar.
 Sento l'aura lusinghiera
 Del primier soave affetto
 Che discende entro del petto
 I miei sensi a ravvissar.

### RECIT. Mr. HARRISON. (JOSHUA.) *Handel.*

'Tis well! Six times the Lord hath been obey'd,
Low in the dust the town shall soon be laid:
Now the seventh sun the gilded domes adorns,
Sound the shrill trumpets, shout, and blow the horns.

## AIR and CHORUS.

Glory to God! the strong cemented walls!
The tott'ring tow'rs, the pond'rous ruin falls:
The nations tremble at the dreadful sound,
Heav'n thunders, tempests roar, and groans the ground.

*Da Capo.*

**END OF THE FIRST ACT.**

## ACT II.

#### CHORUS. (ALEXANDER'S FEAST.) *Handel.*

The many rend the skies with loud applause,
So Love was crown'd, but Music won the cause.

#### SONG. Mr. HARRISON. *De Majo.*

Odi grand' ombra, e placati,
Quel flebile concento,
Fan d'Allesandro i gemiti,
Al publico lamento
Che mai non pùo mentir.

Oimè! che a tante lagrime,
Ai doni, alle preghiere,
Sorde sù gli aspri cardini,
D'Aide le porte nere,
Più non si sanno aprir.

MADRIGAL. Mrs. BILLINGTON,
Mess. W. KNYVETT, HARRISON, and
BARTLEMAN. *Dr. Cooke.*

In the merry month of May,
In a morn by break of day;
Forth I walked by the wood side,
Where as May was in his pride;

There I spyed all alone,
Phillida and Corydone.
Much ado there was, God wot,
For he would love, but she would not.

She said man was never true;
He said none was false to you:
He said he had lov'd her long;
She said Love should have no wrong.

Corydone would kiss her then,
She said maids must kiss no men
Till they did for good and all;
Oh! then, she made the shepherd call
On all the heavens to witness truth
That never lov'd a truer youth.

Thus with many a pretty oath,
Yea and nay, and faith and troth;
Such as silly shepherds use
When they will not love abuse;

Love, which had been long deluded,
Was with kisses sweet concluded;
And Phillida with garland gay
Was crown'd the Lady of the May.

## ANTHEM. *Dr. Croft.*

### VERSE.

Sing unto God, all ye kingdoms of the earth: O sing praises unto the Lord.

### CHORUS.

Cry aloud, and shout, thou inhabitant of Sion, for great is the Holy One of Israel in the midst of thee.

### SONG.  Mr. BARTLEMAN.  *Pergolesi.*

O Lord! have mercy upon me, for I am in trouble: my strength faileth me.

But my hope hath been in thee, O Lord! I have said, Thou art my God.

---

### RECIT.  Mrs. BILLINGTON.
#### (THEODORA.)  *Handel.*

O worse than death indeed! Lead me, ye guards,
Lead me or to the rack or to the flames,
I'll thank your gracious mercy.———

### SONG.

Angels ever bright and fair,
Take, O take me to your care;———
Speed to your own courts my flight,
Clad in robes of virgin white.  *Da Capo.*

## CHORUS.  (SAMSON.)  *Handel.*

Fix'd in his everlasting seat,
JEHOVAH rules the world in state,
Great DAGON rules the world in state,
His thunder roars, heav'n shakes, and earth's aghast,
The stars with deep amaze
Remain in steadfast gaze.
Great DAGON is, of Gods, the first and last.
JEHOVAH is, of Gods, the first and last.

END OF THE SECOND CONCERT.

(No. 3.)

UNDER THE DIRECTION OF

## THE EARL OF DARNLEY.

# CONCERT OF ANTIENT MUSIC,
WEDNESDAY, FEBRUARY 24, 1808.

### ACT I.

Acis and Galatea.　Part First.　⎫
Movement. *(from Handel's Lessons.)*　⎬　*Handel.*
Acis and Galatea.　Part Second.　⎭

### ACT II.

Overture and Chaconne.　⎫
Requiem.　　　　　　　　⎬　*Jomelli.*

Song and Chorus.　Come,　⎫
　if you dare.　　　　　　⎬　*(King Arthur.) Purcell.*

Glee.　Oh! Nanny wilt thou.　　*Carter & Harrison.*

Recit. acc.　Now strike the.　⎫
Chorus.　Break his bands.　　⎬　*(Alex. Feast.) Handel.*
Recit. acc.　Hark! hark!　　　⎬
Song.　Revenge, Timotheus.　⎭

Concerto 4th.　　　(Oboe.)　　　*Handel.*

Song.　Brave Jonathan.　　⎫
Chorus.　Eagles were not.　⎬
Song.　In sweetest harmony.⎬　*(Saul.)　Handel.*
Chorus.　O fatal day!　　　⎬
Song.　Ye men of Judah.　　⎬
Chorus.　Gird on thy sword.⎭

# ACT I.

## ACIS and GALATEA,

### A Serenata.

#### PART THE FIRST.

### CHORUS.

O the pleasures of the plains!
Happy nymphs, and happy swains!
Harmless, merry, free, and gay,
Dance and sport the hours away.
  For us the zephyr blows,
    For us distils the dew,
  For us unfolds the rose,
    And flow'rs display their hue.
  For us the winters rain,
    For us the summers shine,
  Spring swells for us the grain.
    And autumn bleeds the vine    *Da Capo.*

### RECIT. Mrs. BILLINGTON.

Ye verdant plains and woody mountains,
Purling streams and bubbling fountains;
Ye painted glories of the field,
Vain are the pleasures which ye yield:
Too thin the shadow of the grove,
Too faint the gales to cool my love.

### AIR.

Hush! ye pretty warbling choir;
    Your thrilling strains
      Awake my pains,
And kindle fierce desire.
Cease your song, and take your flight,
Bring back my Acis to my sight! *Da Capo.*

### RECIT. Mr. HARRISON.

*Acis.* Lo! here my love!
Turn, Galatea, hither turn thine eyes,
See at thy feet the longing Acis lies.

### AIR.

Love in her eyes sits playing
    And sheds delicious death;
Love on her lips is straying,
    And warbling in her breath.

### RECIT. Mrs. BILLINGTON.

*Galat.* O didst thou know the pains of absent love,
Acis would ne'er from Galatea rove.

### AIR.

As when the dove,
Laments her love,
All on the naked spray;
When he returns,
No more she mourns,
But loves the live-long day.

### DUET. Mrs. BILLINGTON, & Mr. HARRISON, and CHORUS.

Happy we;
What joys I feel! What charms I see?
Of all youths, thou dearest boy!
Of all nymphs, thou brightest fair!
Thou all my bliss, thou all my joy!

## MOVEMENT from HANDEL'S LESSONS

### ACIS and GALATEA.

#### PART THE SECOND.

### CHORUS.

Wretched lovers! fate has past
This sad decree: No joy shall last:
Wretched lovers, quit your dream,
Behold the monster Polypheme!
See what ample strides he takes,
The mountain nods, the forest shakes,
The waves run frighten'd to the shores,
Hark! how the thund'ring giant roars.

#### RECIT. acc. Mr. BARTLEMAN.

*Poly.*     I rage, I melt, I burn,
The feeble god has stabb'd me to the heart,
Thou trusty pine!
Prop of my godlike steps!—I lay thee by.

Bring me an hundred reeds of decent growth,
To make a pipe for my capacious mouth,
In soft enchanting accents let me breathe,
Sweet Galatea's beauty, and my love.

### AIR.

O ruddier than the cherry!
O sweeter than the berry!
  O nymph, more bright
  Than moon-shine night,
Like kidlings blithe and merry!
Ripe as the melting cluster!
No lily has such lustre,
  Yet hard to tame,
  As raging flame,
And fierce as storms that bluster.  *Da Capo.*

### RECIT.

Mrs. BILLINGTON & Mr. BARTLEMAN.

*Poly.*  Whither, fairest, art thou running,
   Still my warm embraces shunning?
*Gal.*  The lion calls not to his prey,
   Nor bids the wolf the lambkin stay,
*Poly.*  Thee, Polyphemus, great as Jove,
   Calls to empire and to love;

        To his palace in the rock,
        To his dairy, to his flock,
        To the grape of purple hue,
        To the plum of glossy blue,
        Wildings which expecting stand,
        Proud to be gather'd by thy hand,

*Gal.*  Of infant limbs to make my food,
        And swill full draughts of human blood!
        Go, monster! bid some other guest,
        I loath the host, I loath the feast.

### RECIT. Mr. HARRISON.

*Acis.*  His hideous love provokes my rage,
        Weak as I am, I must engage.
        Inspir'd by thy victorious charms,
        The God of Love will lend his arms.

### RECIT. Mrs. BILLINGTON.

*Gal.*  Cease, O cease, thou gentle youth,
        Trust my constancy and truth;
        Trust my truth, and powers above,
        The pow'rs propitious still to love.

### TRIO. Mrs. BILLINGTON, Mr. HARRISON, and Mr. BARTLEMAN.

*Acis.*  The flocks shall leave the mountains,
        The woods the turtle dove,
*Gal.*  The nymphs forsake the fountains,
        Ere I forsake my love.

*Poly.* Torture! fury! rage! despair!
 I cannot, cannot bear.
*Acis.* Not show'rs to larks so pleasing,
 Nor sunshine to the bee,
*Gal.* Not sleep to toil so easing,
 As those dear smiles to me.
*Poly.* Fly swift, thou massy ruin, fly!
 Die, presumptuous Acis! die!

RECIT. accomp.   Mr. HARRISON.

*Acis.* Help, Galatea! help, ye parent gods,
 And take me dying to your deep abodes.

CHORUS.

Mourn, all ye muses, weep, ye swains,
 Tune, tune your reeds to doleful strains.
Groans, cries, and howlings, fill the neighb'ring shore,
Ah! the gentle Acis is no more.

AIR.   Mrs. BILLINGTON, and CHORUS.

*Gal.* Must I my Acis still bemoan,
 Inglorious, crush'd beneath that stone.

*Cho.*   Cease, Galatea, cease to grieve,
        Bewail not whom thou canst relieve.
*Gal.*   Must the lovely charming youth,
        Die for his constancy and truth?
*Cho.*   Call forth thy pow'r, employ thy art,
        The goddess soon can heal the smart;
*Gal.*   Say, what comfort can you find,
        For dark despair o'erclouds my mind?
*Cho.*   To kindred gods, the youth return,
        Through verdant plains to roll his urn.

## RECIT. Mrs. BILLINGTON.

*Gal.*   'Tis done; thus I exert my pow'r divine,
        Be thou immortal, though thou art not mine.

## AIR.

Heart, the seat of soft delight,
Be thou now a fountain bright:
Purple be no more thy blood,
Glide thou like a chrystal flood.
Rock, thy hollow womb disclose;
 The bubbling fountain, lo! it flows.
Through the plains he joys to rove,
Murmuring still his gentle love.

## CHORUS.

Galatea, dry thy tears,
Acis now a god appears;
See how he rears him from his bed,
See the wreath that binds his head.
Hail, thou gentle murm'ring stream,
Shepherd's pleasure, muse's theme.
Through the plains still joy to rove,
Murmuring still thy gentle love.

**END OF THE FIRST ACT.**

## ACT II.

### REQUIEM. *Jomelli.*

Requiem eternam dona eis,
Domine, et lux perpetua luceat eis.

Agnus Dei, qui tollis peccata mundi,
Dona eis requiem simpiternam.

Lux eterna luceat eis, Domine,
Cum sanctis tuis in eternum qui pius es.
     Requiem eternum, &c.

Cum sanctis tuis in eternum qui pius es.

### SONG. Mr. HARRISON, and CHORUS.
(KING ARTHUR.)    *Purcell.*

Come, if you dare, our trumpets sound;
Come, if you dare, the foes rebound.

We come, we come, says the double beat of the
    thund'ring drum.
Now they charge on amain ; now they rally again;
  The gods from above the mad labour behold ;
  And pity mankind that will perish for gold.
    The fainting Saxons quit their ground ;
    Their trumpets languish in the sound.
They fly! they fly! Victoria! the bold Britons cry.
Now the victory's won, to the plunder we run;
  Then return to our lasses like fortunate traders,
  Triumphant with spoils of the vanquish'd invaders.

### GLEE. Mrs. BILLINGTON,
### Messrs. W. KNYVETT, HARRISON,
### and BARTLEMAN.

*Carter and Harrison.*

Oh, Nanny, wilt thou gang with me,
  Nor sigh to leave the flaunting town?
Can silent glens have charms for thee,
  The lowly cot and russet gown?
No longer drest in silken sheen,
  No longer deck'd in jewels rare!
Say cans't thou quit the busy scene,
  Where thou art fairest of the fair?

And when, at last, thy love shall die,
   Wilt thou receive his parting breath?
Wilt thou repress each struggling sigh,
   And cheer with smiles the bed of death?
And wilt thou, o'er his much lov'd clay,
   Strew flowers and drop the tender tear?
Nor then regret those scenes so gay,
   Where thou wert fairest of the fair?

### RECIT. acc. Mr. HARRISON.
#### (ALEXANDER'S FEAST.)     *Handel.*

Now strike the golden lyre again,
A louder yet, and yet a louder strain;
Break his bands of sleep asunder,
And rouse him like a ratt'ling peal of thunder.

### CHORUS.

Break his bands of sleep asunder,
Rouse him like a peal of thunder.

### RECIT. acc.

Hark! hark! the horrid sound
Has rais'd up his head;
As awak'd from the dead,
And amaz'd he stares around!

## SONG. Mr. BARTLEMAN.

Revenge! Timotheus cries,
See the Furies arise!
See the snakes that they rear,
How they hiss in their hair,
   And the sparkles that flash from their eyes.
Behold a ghastly band,
Each a torch in his hand:
   Those are Grecian ghosts
That in battle were slain,
And unbury'd remain,
Inglorious on the plain.         *Da Capo.*

## SCENE.    (FROM SAUL.)      *Handel.*

### SONG. Mr. BARTLEMAN.

Brave JONATHAN his bow ne'er drew
But wing'd with death his arrow flew,
   And drank the blood of slaughter'd foes;
Nor drew great SAUL his sword in vain,
It reek'd where e'er he dealt his blows
   With entrails of the mighty slain.

### CHORUS.

Eagles were not so swift as they,
Nor lions with so strong a grasp
   Held fast and tore the prey.

## SONG. Mrs. BILLINGTON.

In sweetest harmony they liv'd,
Nor death their union could divide;
The pious son ne'er left his father's side,
But him defending, bravely dy'd:
A loss too great to be surviv'd!
For Saul, ye maids of Israel moan,
To whose indulgent care
You owe the scarlet and the gold you wear,
And all the pomp in which your beauty long has shone.

## CHORUS.

Oh, fatal day! how low the mighty lie!
Oh, Jonathan, how nobly didst thou die!
    For thy King and Country slain.

## SOLO. Mrs. BILLINGTON.

For thee, my brother Jonathan,
    How great is my distress,
      What language can my grief express?
Great was the pleasure I enjoy'd in thee,
And more than woman's love,
    Thy wond'rous love to me.

## CHORUS.

O fatal day! how low the mighty lie!
    Where, Israel is thy glory fled?
Spoil'd of thy arms, and sunk in infamy,
    How canst thou raise again thy drooping head?

### SONG.   Mr. BARTLEMAN.

Ye men of Judah, weep no more;
    Let gladness reign in all our host!
For pious David will restore
    What Saul by disobedience lost.
The Lord of Hosts is David's friend,
And conquest will his arms attend.

## CHORUS.

Gird on thy sword, thou man of might,
    Pursue thy wonted fame;
Go on, be prosperous in fight,
    Retrieve the Hebrew name.
Thy strong right hand with terror arm'd,
    Shall thy obdurate foes dismay;
While others, by thy virtue charm'd,
    Shall crowd to own thy righteous sway.

END OF THE THIRD CONCERT.

(No. 4.)

UNDER THE DIRECTION OF

## THE EARL OF UXBRIDGE.

# CONCERT OF ANTIENT MUSIC,

THURSDAY, MARCH 3, 1808.

### ACT I.

Overture. (*Samson.*) *Handel.*
Chorus. Fall'n is the foe. (*Judas Mac.*) *Handel.*
Spartan Song. I have been young. *Dr. Cooke.*
Duet. O what pleasure. (*Alex. Balus.*) *Handel.*
The Passions. (*Solomon.*) *Handel.*
Concerto 11th. (Grand.) *Handel.*
Chorus. He gave them. (*Israel in Egypt.*) *Handel.*
Recit. acc. Berenice ove sei.
Song. Ombra che pallida. } (*Lucio Vero*) *Jomelli.*
Scene in Bonduca. Divine Andate. *Purcell.*

### ACT II.

Overture and Minuet. (*Iphigenia.*) *Gluck.*
Recit. My arms.
Song. Sound and alarm. } (*Judas Mac.*) *Handel.*
Chorus. We hear.
Glee. Let not rage. *Dr. Arne.*
Song. Why do the nations.
Chorus. Let us break. } (*Messiah.*) *Handel.*
Concerto 2nd. *Corelli.*
Canzonet. Soft Cupid. *Travers.*
Song. Posso morir. (*Arminius.*) *Handel.*
Chorus. Around let acclamations. (*Athalia.*) *Handel.*

## ACT I.

### CHORUS. (JUDAS MACC.) *Handel.*

Fall'n is the foe; so fall thy foes, O Lord!
When warlike JUDAS wields his righteous sword.

### SPARTAN SONG. *Dr. Cooke.*

*Old Man.* I have been young, tho' now grown old;
Hardy in field, in battle bold.
I am young still, let who dares try,
I'll conquer, or in combat die!
Whatever ye can do or tell,
I one day did you both excell;

*Young Man.* You have been young, tho' now grown old;
Hardy in field, in battle bold.
I am young now, let who dares try,
I'll conquer or in combat die!

*Chorus of Boys.* Whatever ye can do or tell,
             We one day will you both excell.

DUET. Mrs. BILLINGTON, & Mrs. VAUGHAN.
(ALEXANDER BALUS.)         *Handel.*

O! what pleasures past expressing,
Flow from pure and constant love;
All is joy, and all is blessing,
Which the circling hours improve.

## *THE PASSIONS.*

RECIT. Mr. HARRISON. (SOLOMON.) *Handel.*

Sweep, sweep the strings to soothe the royal fair,
And rouse each passion with th' alternate air.

### AIR and CHORUS.

Music spread thy voice around,
Sweetly flow the lulling sound.

### AIR and CHORUS.

Now a different measure try,
Shake the dome and pierce the sky;
Rouse us next to martial deeds:
Clanking arms and neighing steeds
Seem in fury to oppose--
Now the hard-fought battle glows.

### RECIT. and CHORUS.

Then, at once, from rage remove,
Draw the tear from hopeless love;
Lengthen out the solemn air,
Full of death and wild despair.

### RECIT.

Next the tortur'd soul release,
And the mind restore to peace.

### AIR and CHORUS.

Thus rolling surges rise,
   And plough the troubled main;
But soon the tempest dies,
   And all is calm again.

---

CHORUS.     (ISRAEL IN EGYPT.)     *Handel.*

He gave them hailstones for rain; fire mingled with the rain ran along upon the ground.

RECIT. Mrs. BILLINGTON.

(Lucio Vero.) *Jomelli.*

Berenice, ove sei?
Qual lugubre apparato
Di Spavento, e di lutto!
Qual di tenebre ed'ombre
Reggio dolente e fiera!
Forse quì di Tieste
Si rinovan le Cene? o langue il giorno
Fuggitivi così, perche tra queste
Soglie funeste, oh Dio!
Trucidato morì l'Idol mio?
Ahimè! sogno o son desta?
Odo—o parmi d'udir—la voce—il pianto—
Del moribondo Sposo!—ahi son pur questi
Gemiti di chi langue
Singulti di chi spira—E quell' oscura
Caligine profonda,
Di là s'inalza, e mostra
Non so qual simulacro a gli occhi miei—
Quella—si quella—oh Dei! gìa la ravviso,
E del mio Vologeso
L'ombra mesta e dolente:
Ah barbaro Tiranno!
Il mio sposo uccidesti
Io non m'inganno.

## SONG.

Ombra che pallida
Fai qui soggiorno;
Larva che squallida
Mi gira intorno
Perchè mi chiami?
Che vuoi da me?
Se pace brami
Ombra infelice
In Berenice, no, pace non vè.

## MUSIC in BONDUCA.

### RECIT. Mr. HARRISON. *Purcell.*

Divine ANDATE! president of war,
The fortune of the day declare—
   Shall we to the Romans yield?
   Or shall each arm that wields a spear,
Strike it through a massy shield,
And dye with Roman blood the field?

### DUET. Mr. HARRISON & Mr. BARTLEMAN.

   To arms! your ensigns straight display,
   Now set the battle in array;
   The Oracle for war declares,
    Success depends upon our hearts and spears.
Britons, strike home, revenge your country's wrongs,
Fight, and record yourselves in Druid's songs.

END OF THE FIRST ACT.

## ACT II.

### RECIT. Mr. HARRISON.
(JUDAS MACC.) *Handel.*

My arms! Against this Gorgias will I go—
The Idumean governor shall know,
How vain, how ineffective his design,
While rage his leader, and Jehovah mine.

### AIR.

Sound an alarm!—Your silver trumpets sound,
And call the brave, and only brave, around——
Who listeth, follow——To the field again:
Justice with courage is a thousand men. *Da Capo.*

### CHORUS.

We hear, we hear the pleasing, dreadful call,
And follow thee to conquest: If to fall,
For laws, religion, liberty, we fall.

## GLEE. Mrs. BILLINGTON, Messrs. HARRISON, W. KNYVETT, and BARTLEMAN. *Dr. Arne.*

Let not rage, thy bosom firing,
    Pity's softer claim remove;
Spare a heart that's just expiring,
    Forc'd by duty, rack'd by love.

Each ungentle thought suspending,
    Judge of mine, by thy soft breast;
Nor with rancour, never ending,
    Heap fresh sorrows on th' opprest.

Heaven, that every joy has crost,
    Ne'er my wretched fate can mend;
I, alas! at once have lost,
    Father, brother, lover, friend.

---

## SONG. Mr. BARTLEMAN. (MESSIAH.) *Handel.*

Why do the nations so furiously rage together; and why do the people imagine a vain thing?

The kings of the earth rise up, and the rulers take counsel together against the Lord, and against his anointed.

## CHORUS.

Let us break their bonds asunder, and cast away their yokes from us.

---

### CANZONETT. *Travers.*
### Mess. HARRISON, W. KNYVETT and BARTLEMAN.

Soft Cupid, wanton, am'rous boy,
    The other day mov'd with my lyre,
In flatt'ring accents spoke his joy
    And utter'd thus his fond desire:

O raise thy voice, one song I ask;
    Touch then th' harmonious string;
To Thyrsis easy is the task,
    Who can so sweetly play and sing.

Two kisses from my mother dear,
    Thyrsis, thy due reward shall be;
None like Beauty's Queen is fair,
    Paris has vouch'd this truth for me.

I straight reply'd, thou know'st alone
    That brightest Chloe rules my breast;
I'll sing thee two instead of one,
    If thou'lt be kind, and make me blest.

[ 55 ]

One kiss from Chloe's lips, no more
  I crave; he promis'd me success,
I play'd with all my skill and pow'r,
  My glowing passion to express.

But, O my Chloe, beauteous maid!
  Wilt thou the wish'd reward bestow?
Wilt thou make good what Love has said,
  And by thy grant his power show?

I play'd with all my skill and pow'r,
  My glowing passion to express.

SONG. Mrs. BILLINGTON. (ARMINIUS.) *Handel.*

Posso morir; ma vivere
E non amare, oh Dei!
L'alma de' affetti miei,
Non posso, nò.

Se amor da vita all'anima,
Tormi dal seno amore,
Senza involarmi il core,
No, non si può.        *Da Capo.*

CHORUS.     (ATHALIA.)     *Handel.*

Around let acclamations ring,
Hail, royal youth! long live the king!

SOLO.   Mr. Wm. KNYVETT.

Reviving JUDAH shall no more
Detested images adore;
We'll purge, with a reforming hand,
Idolatry from out the land:
May God from whom all mercies spring,
Bless the true Church, and save the King!

GRAND CHORUS.

Bless the true Church, and save the King!

END OF THE FOURTH CONCERT.

(No. 5.)

UNDER THE DIRECTION OF
*The Earl of DARNLEY,*
*For Lord Viscount FITZWILLIAM.*

# CONCERT OF ANTIENT MUSIC,

WEDNESDAY, MARCH 9, 1808.

## ACT I.

Overture. *(Occasional Oratorio.)* ⎫
Chorus. How excellent. *(Saul.)* ⎪
Duet. What's sweeter. *(Joseph.)* ⎪
Recit. acc. First & chief. ⎫ *Il Pensieroso.* ⎪
Song. Sweet Bird. ⎭ ⎪
Recit. If I give thee. ⎫ *(L'Allegro.)* ⎪
Song. Mirth admit me. ⎭ ⎬ *Handel.*
Song. Oft on a plat. *(Il Pensieroso.)* ⎪
Recit. If I give thee. ⎫ ⎪
Song. Let me wander ⎬ *(L'Allegro.)* ⎪
Chorus. And young and. ⎭ ⎪
Concerto 1st. *(Grand.)* ⎪
Chorus. The Lord our Enemy. *(Esther.)* ⎭

## ACT II.

Overture 7th. *Martini.*
Music in Macbeth. *Locke.*
Glee. Shepherds I have.
Frost Scene. *(King Arthur.)* *Purcell.*
Concerto 6th *Corelli.*
Canzonet. I, my dear. *Travers.*
Song. Se pur cara. *(Alceste.)* *Gluck.*
Chorus. Gloria Patri. *Leo.*

I

## ACT I.

### CHORUS. (SAUL.) *Handel.*

How excellent thy name, O Lord!
   In all the world is known!
Above all heavens, O King ador'd,
   How hast thou set thy glorious throne!

### AIR. Mrs. VAUGHAN.

An infant rais'd by thy command,
   To quell thy rebel foes,
Could fierce Goliath's dreadful hand,
   Superior in the fight oppose.

### TRIO-CHORUS.

Along the monster Atheist strode,
   With more than human pride!
And armies of the living God,
   Exulting in his strength defy'd.

## SEMI-CHORUS.

The youth inspir'd by thee, O Lord !
   With ease the boaster slew ;
Our fainting courage soon restor'd,
   And headlong drove that impious crew.

## CHORUS.

How excellent thy name, O Lord !
   In all the world is known !
Above all heavens, O King ador'd,
   How hast thou set thy glorious throne !
        HALLELUJAH !

---

### DUET. Mrs. BILLINGTON, & Mr. HARRISON.
(JOSEPH.)

What's sweeter than the new-blown rose ?
Or breezes from the new-mown close ?
What's sweeter than an April morn ?
Or May-day's silver fragrant thorn ?
What than Arabia's spicy grove ?
O sweeter far the breath of love.

---

### RECIT. acc. Mrs. BILLINGTON.
(IL PENSIEROSO.)

First and chief, on golden wing,
The cherub Contemplation bring,

And the mute silence hist along,
'Less Philomel will deign a song;
In her sweetest, saddest plight,
Smoothing the rugged brow of night.

### SONG.

Sweet bird! that shun'st the noise of folly,
Most musical, most melancholy!
Thee, chauntress, oft the woods among
I woo, to hear thy even-song.

### RECIT. Mr. BARTLEMAN.
#### (L'Allegro.)

If I give thee honour due,
Mirth, admit me of thy crew.

### SONG.

Mirth, admit me of thy crew,
To listen how the hounds and horn
Clearly rouse the slumb'ring morn,
From the side of some hoar hill,
Thro' the high wood echoing shrill.

## SONG.  Mr. HARRISON.
### (IL PENSIEROSO.)

Oft on a plat of rising ground,
I hear the far-off curfew sound;
Over some wide water'd shore,
Swinging slow, with sullen roar.

Or, if the air will not permit,
Some still, removed place will fit,
Where glowing embers, thro' the room,
Teach light to counterfeit a gloom.

## RECIT.  Mrs. VAUGHAN.
### (L'ALLEGRO.)

If I give thee honour due,
Mirth, admit me of thy crew.

## SONG.

Let me wander, not unseen
By hedge row elms, on hillocks green,
There the ploughman near at hand,
Whistles o'er the furrow'd land;
And the milkmaid singeth blithe;
And the mower wets his scythe;

And every shepherd tells his tale
Under the hawthorn, in the dale.
Or, let the merry bells ring round,
And the jocund rebecks sound
To many a youth, and many a maid,
Dancing in the chequer'd shade.

### CHORUS.

And young and old come forth to play,
On a sunshine holiday,
'Till the live-long day-light fail.
Thus pass'd the day, to bed they creep,
By whisp'ring winds soon lull'd asleep.

### CHORUS. (Esther.)

The Lord our enemy has slain;
Ye Sons of Jacob sing a cheerful strain.

### QUINTETTO.

Sing songs of praise, bow down the knee,
The worship of our God is free.

## CHORUS.

The Lord our enemy has slain;
Ye Sons of Jacob sing a cheerful strain;
For ever blessed be thy holy name,
Let Heav'n and Earth his praise proclaim.

## DUET.

The Lord his people shall restore,
And we in Salem shall adore.

## CHORUS.

For ever blessed be his holy name,
Let Heav'n and Earth his praise proclaim.

## DUET.

Mount Lebanon his firs resigns;
Descend ye cedars, haste ye pines,
To build the Temple of the Lord,
For God his people has restor'd.

## CHORUS.

For ever blessed be his holy name,
Let Heav'n and Earth his praise proclaim.

**END OF THE FIRST ACT.**

## ACT II.

MUSIC in MACBETH.  *Locke*

### 1st *Witch.*

Speak, sister, speak; is the deed done?

### 2d *Witch.*

Long ago, long ago,
  Above twelve glasses since have run:
Ill deeds are seldom slow,
Or single; but follow'ng crimes on former wait,
The worst of creatures fastest propagate:

1st *Witch.*  Many more murders must this one ensue,
  Dread horrors still abound
  In ev'ry place around
  As if in death were found
    Propagation new.
  He shall, he will,
  He must spill
  Much more blood,
And become worse, to make his title good.

## CHORUS.

He shall, he will,
He must spill
Much more blood,
And become worse, to make his title good.
1st *Witch.*  Now let's dance.
2d *Witch.*   Agreed, agreed:

## CHORUS.

Agreed, agreed.
We should rejoice when good kings bleed.

## AIR.

When cattle die, about we go:
When light'ning and dread thunder
Rend stubborn rocks asunder,
And fill the world with wonder,
    What should we do?

## CHORUS.

Rejoice—we should rejoice.

## AIR.

When winds and waves are warring,
Earthquakes the mountains tearing,
And monarchs die despairing,
    What should we do?

## CHORUS.

Rejoice—we should rejoice.

## AIR.

Let's have a dance upon the heath,
We gain more life by Duncan's death,
Sometimes like brinded cats we shew,
Having no music but our mew,
To which we dance in some old mill,
Upon the hopper, stone, or wheel;
To some old saw, or bardish rhime,
Where still the mill-clack does keep time:
Sometimes about a hollow tree,
Around, around, dance we;
And thither the chirping crickets come,
And beetles sing in drowsy hum;
Sometimes we dance o'er ferns or furze,
To howls of wolves, or barks of curs:
Or if with none of these we meet,
We dance to the echoes of our feet.

## CHORUS.

At the night-raven's dismal voice,
When others tremble we rejoice,
And nimbly, nimbly dance we still,
To the echoes from the hollow hill.

## RECIT.

1*st Witch.*   Hecate, Hecate, come away!
*Hecate.*   Hark! hark! I'm call'd.

## AIR.

*Hecate.*   My little merry airy spirit, see! see!
       Sits in a foggy cloud and waits for me.

## RECIT.

1*st Witch.*   Hecate! Hecate!

## AIR.

*Hecate.*   Thy chirping voice I hear,
    So pleasing to my ear,
    To which I haste away,
    With all the speed I may.

### RECIT.

*Hecate & Witches.* Where's Puckle?
*3d Witch.* Here!
*Hecate.* Where's Stradling?
*2d Witch.* Here!
*1st Witch.* And Hopper too,
And Hellway too,
We want but you!

### CHORUS.

Come away, come away
Make up the account.

### RECIT.

With new-fall'n dew,
From church-yard yew,
I will but 'noint,
And then I'll mount,
Now I'm furnished for my flight.

### AIR and CHORUS.

Now we go, now we fly,
MALKIN, my sweet spirit and I:
O what a dainty pleasure is this.
To sail in the air,
When the moon shines fair,

To sing, to dance, to toy and kiss:
Over woods, high rocks, and mountains,
    Over hills, and misty fountains,
    Over steeples, towns and turrets,
We fly by night, 'mongst troops of spirits.

## CHORUS.

Round, around, around about;
    All ill come running in,
    All good keep out.

## RECIT.

*1st Witch.*    Here's the blood of a bat!
*Hecate.*    O put in that—put in that!
*1st Witch.*    Here's lizard's brain!
*Hecate.*    Put in a grain!
*1st Witch.*    Here's juice of toad; here's oil of adder,
    Which will make the charm grow madder.

## QUARTETTO.

Put in all these, 'twill raise the stench.

## RECIT.

*Hecate.* Hold! here's three ounces of a red-hair wench!

## CHORUS.

Round, around, around about;
    All ill come running in,
    All good keep out.

GLEE for Four Voices. Mrs. BILLINGTON,
Messrs. HARRISON, W. KNYVETT,
and BARTLEMAN.

>Shepherds, I have lost my love,
>    Have you seen my ANNA?
>Pride of ev'ry shady grove,
>    Upon the banks of Banna.
>
>I for her my home forsook,
>    Near yon misty mountain;
>Left my flock, my pipe, my crook,
>    Green wood, shade and fountain.
>
>Never shall I see them more
>    Until her returning;
>All the joys of life are o'er,
>    From gladness chang'd to mourning.
>
>Whither is my charmer flown,
>    Shepherds tell me whither?
>Ah! woe is me, perhaps she's gone
>    For ever and for ever!

FROST SCENE.    (KING ARTHUR.)    *Purcell*
   (CUPID.)   Mrs. VAUGHAN.

>What ho! thou Genius of this isle! what ho!
>Ly'st thou asleep beneath those hills of snow?
>What ho! stretch out thy lazy limbs; awake!
>And winter from thy furry mantle shake.

(COLD GENIUS.) Mr. BARTLEMAN.

What power art thou, who from below
Hast made me rise, unwillingly and slow,
From beds of everlasting snow ?
See'st thou how stiff, and wond'rous old,
Far, far unfit to bear the bitter cold ?
I can scarcely move, or draw my breath;
Let me freeze again to death.

### CUPID.

Thou doating fool, forbear, forbear,
What, dost thou dream of freezing here ?
    At love's appearing,
    All the sky clearing,
The stormy winds their fury spare.
Thou doating fool, fobear, forbear,
What, dost thou dream of freezing here ?
    Winter subduing,
    Spring renewing,
My beams create a more glorious spring,
Thou doating fool, forbear, forbear,
What, dost thou dream of freezing here ?

### COLD GENIUS.

Great Love ! I know thee now !
Eldest of the gods art thou !
Heaven and earth by thee were made ;
    Human nature
    Is thy creature,
Every where art thou obey'd.

## CUPID.

'Tis I that have warm'd you:
In spite of cold weather,
I've brought you together;
'Tis I that have warm'd you.

## CHORUS.

'Tis Love that has warm'd us;
In spite of cold weather,
He brought us together;
'Tis Love that has warm'd us.

## CANZONET.
Mr. HARRISON & Mr. BARTLEMAN. *Travers.*

I, my dear, was born to-day,
So all my jolly comrades say;
They bring me music, wreaths, and mirth,
And ask to celebrate my birth.

Little, alas! my comrades know,
That I was born to pain and woe;
To thy denial, to thy scorn,
Better I had ne'er been born:
I wish to die, ev'n whilst I say,
I, my dear, was born to-day.

I, my dear, was born to-day,
Shall I salute the rising ray?
Well-spring of all my joy and woe,
Clotilda, thou alone dost know.

Shall the wreath surround my hair,
Or shall the music please my ear?
Shall I, my comrades' mirth receive,
And bless my birth, and wish to live?

Then let me see great Venus chase,
Imperious anger from thy face:
Then let me hear thee smiling say,
Thou, my dear, wert born to-day.

~~~~~

SONG.    Mrs. BILLINGTON. (ALCESTE.)    *Gluck.*

Se pur cara è a me la vita,
E per tè mio dolce amor;
Ah per te mi sia rapita!
E morrò felice allor.

T' amorò sino alla morte,
Fin colà fra l'ombre eterne,
D'una tenera consorte,
Trionfar vedrassi il cor.

## CHORUS. *Leo.*

Gloria Patri, Filio, et Spiritui Sancto: sicut erat in principio, et nunc, et semper, et in secula seculorum. Amen.

END OF THE FIFTH CONCERT.

(No. 6.)

UNDER THE DIRECTION OF

*The Earl of UXBRIDGE.*

# CONCERT OF ANTIENT MUSIC,

WEDNESDAY, MARCH 16, 1808.

## ACT I.

Overture. (*Otho.*) *Handel.*
Chorus. He spake the word. (*Is. in Egypt.*) *Handel.*
Canzonet. Haste, my Nannette. *Travers.*
Trio and Chorus. Disdainful of danger. } (*Juda. Macc.*) *Handel.*
Quartet. and Chorus. Concinamus. *Reading.*
Concerto 1st. (Opera 3rd.) *Geminiani.*
Recit. It must be so. }
Song. Pour forth no more. } (*Jephthah.*) *Handel.*
Chorus. No more to Ammon's. }
Recit. acc. Grazia vi rendo. }
Song. A compir gia. } (*Semiram*) *Guglielmi.*
Chorus. From the censer. (*Solomon.*) *Handel.*

## ACT II.

Overture. }
Recit. Behold the Nations. }
Chorus. O Baal! Monarch. } (*Deborah*) *Handel.*
Recit. No more, ye infidels. }
Chorus. Lord of eternity! }
Recit. acc. Justly these evils. }
Song. Why does the God of. } (*Samson.*) *Handel.*
Introduction and Chorus. }
Ye Sons of Israel. } (*Joshua.*) *Handel.*
Madrigal. Flora gave me. *Wilbye.*
Concerto 11th. *Corelli.*
Chorus. The Gods, who chosen. (*Athalia.*) *Handel.*
Recit. Come, come, no time. }
Song. Let the bright. } (*Samson.*) *Handel.*
Chorus. Let their celestial. }

# ACT I.

CHORUS. (ISRAEL IN EGYPT.) *Handel.*

He spake the word, and there came all manner of flies and lice in all their quarters.

And the locusts came without number, and devoured the fruits of the ground.

### CANZONET.
Mrs. BILLINGTON and Mr. BARTLEMAN.
*Travers.*

Haste, my Nannette, my lovely maid,
Haste to the bower thy swain has made:
For thee alone I made the bow'r,
And strew'd the couch with many a flower.
None but my sheep shall near us come;
Venus be prais'd, my sheep are dumb.

Great God of love, take thou my crook,
To keep the wolf from Nannette's flock.
Guard thou the sheep to her so dear;
My own, alas! are less my care.

But of the wolf if thou'rt afraid,
Come not to us to call for aid:
For with her swain my love shall stay,
Tho' the wolf stroll, and the sheep stray.

### TRIO and CHORUS.
#### (JUDAS MACC.) *Handel.*

Disdainful of danger, we'll rush on the foe,
That thy power, O Jehovah! all nations may know.

### QUARTETTO. Mrs. VAUGHAN,
### Messrs. HARRISON, W. KNYVETT,
### and BARTLEMAN. *Reading.*

Concinamus; O sodales
Eja! quid silemus?
Nobile canticum,
Dulce melos, domum,
Dulce domum resonemus.

## CHORUS.

Domum, domum! dulce domum!
Dulce domum resonemus.

### SOLI.

Appropinquat ecce! felix
Hora gaudiorum,
Post grave tedium
Advenit omnium,
Meta petita laborum,

### CHORUS.

Domum, domum! dulce domum!
Dulce domum resonemus.

### SOLI.

Ridet annus; prata rident,
Nosque rideamus.
Jam repetit domum
Daulius advena,
Nosque domum repetamus.

### CHORUS.

Domum, domum! dulce domum!
Dulce domum resonemus.

## SOLI.

Musa libros mitte fessa;
Mitte pensa dura;
Mitte negotium,
Jam datur otium,
Me mea mittito cura.

## CHORUS.

Domum, domum! dulce domum!
Dulce domum resonemus.

---

### RECIT. Mr. BARTLEMAN. (JEPHTHAH.) *Handel.*

It must be so: or these vile Ammonites
(Our lordly tyrants now these eighteen years)
Will crush the race of Israel.————
Since Heaven vouchsafes not, with immediate choice,
To point us out a leader as before.
Ourselves must chuse: and who so fit a man
As Gilead's son, our brother, valiant Jephthah?
True, we have slighted, scorn'd, expell'd him hence,
As of a stranger born; but well I know him!
His generous soul disdains a mean revenge,
When his distressful country calls his aid:
And, perhaps, Heaven may favour our request,
If with repentant hearts we sue for mercy.

## SONG.

Pour forth no more unheeded prayers
    To idols deaf and vain;
No more with vile unhallow'd airs
    The sacred rites profane.     *Da Capo.*

## CHORUS.

No more to Ammon's God and King,
  Fierce Moloch, shall our cymbals ring
In dismal dance around the furnace blue.
    Chemosh no more
    Will we adore
With timbrell'd anthems to Jehovah due.

---

RECIT. acc.   Mrs. BILLINGTON.
    (SEMIRAMIDE.)     *Guglielmi.*

Grazie vi rendo, pietosi Numi!
Alfin v'intesi,
Alfine so qual vittime chiede l'estinto sposo.
Azema, non ci perdiam,
Potrebbe prevenirci l'indegno.
Misera! a quanti affanni serbata io sono!
E quando con me vi placarete, astri tiranni!

## SONG.

A compir già vo' l'impressa,
Non temer, ti rasserena.
Senza affanno, in quella pena
Non gli posso, oh Dio! lasciar.
Non ascolto in tal momento,
Che il mio zelo, e l'onor mio,
Sol con questi ognor desio
I miei passi regolar.

## CHORUS. (SOLOMON.) *Handel.*

From the censer curling rise
Grateful incense to the skies;
Heaven blesses David's throne,
Happy, happy, Solomon.

### DOUBLE CHORUS.

Live, live for ever, pious David's son;
Live, live for ever, mighty Solomon.

END OF THE FIRST ACT.

## ACT II.

RECIT.   Mr. SALE.   (DEBORAH.)   *Handel.*

Behold the nations all around,
What God-like Baal is renown'd?
To him your stubborn tribes would bow,
Did but the slaves their duty know.

### CHORUS.

O Baal! monarch of the skies,
To whom unnumber'd temples rise!
From thee the sun, immensely bright,
Receiv'd his radiant robes of light:
By thee with stars the heavens glow;
The ocean swells, the rivers flow;
The vales with verdure are array'd,
The flow'rs perfume the thicket's shade:
And 'tis by the event confess'd,
Thy votaries alone are bless'd.

RECIT. Mr. J. B. SALE.

No more, ye infidels, no more!
False is the God whom ye adore;
A dull, brute idol, whose detested shrine,
None but such wretches can believe divine.

CHORUS.

Lord of eternity! who hast in store
Plagues for the proud, and mercy for the poor;
Look down, look down, from thy cœlestial throne,
And let the terrors of thy wrath be known!
Plead thy just cause, thy awful pow'r disclose,
Avenge thy servants, and confound their foes!

RECIT. acc. Mr. HARRISON.
(SAMSON.) *Handel.*

Justly these evils have befallen thy son;
Sole author I, sole cause. My griefs for this
Forbid mine eyes to close, or thoughts to rest;
But now the strife shall end; me overthrown,
Dagon presumes to enter lists with God;
Who, thus provok'd, will not connive, but rouse
His fury soon, and his great name assert.
Dagon shall stoop, 'ere long he quite despoil'd
Of all those boasted trophies won on me.

## SONG.

Why doth the God of Israel sleep?
   Arise with dreadful sound,
    And clouds encompass'd round,
Then shall the heathen hear thy thunder deep.
The tempest of thy wrath now raise,
   In whirlwinds them pursue,
   Full fraught with vengeance due,
'Till shame and trouble all thy foes shall seize.

---

INTRODUCTION & CHORUS. (JOSHUA.) *Handel.*

Ye sons of Israel, every tribe attend,
Let grateful songs and hymns to heaven ascend,
In Gilgal, and on Jordan's banks proclaim
One first, one last, one great Jehovah's name.

---

MADRIGAL. Mrs. BILLINGTON,
Mrs. VAUGHAN, Messrs. HARRISON,
W. KNYVETT, and BARTLEMAN. *Wilbye.*

   Flora gave me fairest flowers,
     None so fair in Flora's treasure:
   These I plac'd in Phillis' bowers;
     She was pleas'd, and she's my pleasure;
    Smiling meadows seem to say,
    Come, ye wantons, here to play.

## CHORUS. (ATHALIA.) *Handel.*

The gods, who chosen blessings shed
On Majesty's anointed head;
  For thee their care will still employ
  And brighten all thy fears to joy.

---

## RECIT. Mrs. BILLINGTON. (SAMSON.) *Handel.*

Come, come: no time for lamentation now;
No cause for grief; Samson like Samson fell;
Both life and death heroic. To his foes
Ruin is left; to him eternal fame.

## SONG.

Let the bright Seraphim in burning row,
Their loud, up-lifted angel-trumpets blow:
Let the cherubic host, in tuneful choirs,
Touch their immortal harps with golden wires:
                             *Da Capo.*

## CHORUS.

Let their cœlestial concerts all unite,
Ever to sound his praise in endless blaze of light.

**END OF THE SIXTH CONCERT.**

(No. 7.)

UNDER THE DIRECTION OF

## The Earl FORTESCUE.

# CONCERT OF ANTIENT MUSIC,

WEDNESDAY, MARCH 23, 1808.

### ACT I.

Overture 2nd. (Op. 8.) *Martini.*
Chorus. See from his post. (*Belshazzar.*) *Handel.*
Trio and Chorus. Fear no danger. } (*Dido & Æneas.*) *Purcell.*
Song. To God our strength. Chorus. Prepare the hymn. } (*Occ. Orat.*) *Handel.*
Song. O magnify the Lord. (*Anthem.*) *Handel.*
Chorus. Avert these omens. (*Semele.*) *Handel.*
Madrigal. Dissi all'amata. *Luca Marenzio.*
Concerto 4th. (*Opera Quarto.*) *Avison.*
Recit. acc. But bright. Air & Chorus. As from. } (*Dryden's Ode.*) *Handel.*

### ACT II.

Opening and Chorus. We praise thee, O God. } (*Dett. Te Deum.*) *Handel.*
Song. Softly rise. Chorus. Ye southern. } (*Solomon.*) *Dr. Boyce.*
Chorus. O God, who in thy. (*Joseph.*) *Handel.*
Duet and Chorus. See the conqu'ring. } (*Judas Macc.*) *Handel.*
Chorus. Venus laughing. (*Theodora.*) *Handel.*
Song. Donzelle semplici. (*Iphigenia.*) *Gluck.*
Scene. Already see. (*Saul.*) *Handel.*
Concerto 10th. *Corelli.*
Chorus. Gloria Patri. (*Jubilate.*) *Handel.*

# ACT I.

### CHORUS. (BELSHAZZAR.) *Handel.*

See from his post EUPHRATES flies,
The stream withdraws its guardian wave,
Fenceless the queen of cities lies.

### SEMI-CHORUS.

Why, faithless river, dost thou leave
Thy charge to hostile arms a prey?
Expose the lives thou ought'st to save,
Prepare the fierce invaders' way,
And, like false man, thy trust betray?

### SEMI-CHORUS.

EUPHRATES hath his task fulfill'd,
But to divine decree must yield,
While BABEL, queen of cities reign'd,
Her flood, her guardian, was ordain'd.

## SEMI-CHORUS.

Why, faithless river,
Like false man, thy trust betray?

## SEMI-CHORUS.

Not to superior pow'r give place,
And but the doom of Heav'n obey.

## FULL-CHORUS.

Of things on earth, proud man must own,
Falsehood is found in man alone.

---

TRIO.　　(DIDO AND ÆNEAS.)　　*Purcell.*
　　and CHORUS.

Fear no danger to ensue,
The hero loves as well as you;
Ever gentle, ever smiling,
And the cares of life beguiling:　　*Da Capo.*
Cupids strew your paths with flow'rs,
Gather'd from Elysian bowers.　　*Da Capo.*

## SONG.  Mr. BARTLEMAN.
### (Occ. Oratorio.)   *Handel.*

To God, our strength, sing loud and clear,
  Sing loud to God our King,
To Jacob's God, that all may hear
  Loud acclamations ring;
Prepare the hymn, prepare the song,
  The timbrel hither bring;
The cheerful psaltry bring along,
  And harp with pleasant string.

### CHORUS.

Prepare the hymn, prepare the song,
  The timbrel hither bring;
The cheerful psaltry bring along,
  And harp with pleasant string.

---

## SONG.  Mrs. VAUGHAN.  (Anthem.)  *Handel.*

O magnify the Lord, and worship him upon his holy hill.  For the Lord our God is holy.

CHORUS.   (SEMELE.)   *Handel.*

Avert these omens, all ye powers,
Some god, averse, our holy rites controuls;
O'erwhelm'd with sudden night the day expires!
Ill-boding thunder on the right hand rolls;
  And Jove himself descends in show'rs
   To quench our late propitious fires.

MADRIGAL.   Mrs. BILLINGTON,
Mess. HARRISON, Wm. KNYVETT, and
  BARTLEMAN.   *Luca Marenzio.*

 Dissi all'amata mia
 Lucida stella
 Che più d'ogn' altro luce
 Ed al mio cor adduce
 Fiamme, strali e catene
  Ch' ogn' or mi danno pene;
 Deh! morirò cor mio?
 Si, morirai,
 Ma non per mio desio.

RECIT. acc. Mrs. BILLINGTON.
  (DRYDEN'S ODE.)   *Handel.*

But bright Cecilia rais'd the wonder high;
When to her organ vocal breath was giv'n,
  An angel heard,
  And straight appear'd,
Mistaking earth for heaven.

## SOLO and CHORUS.

As from the power of sacred lays,
　　The spheres began to move,
And sung the great Creator's praise
　　To all the bless'd above;
So when the last and dreadful hour,
This crumbling pageant shall devour,
The trumpet shall be heard on high;

## CHORUS.

The dead shall live, the living die,
And music shall untune the sky.

**END OF THE FIRST ACT.**

## ACT II.

### OPENING and CHORUS.
#### (Dettingen te deum.) *Handel.*

We praise thee, O God; we acknowledge thee to be the Lord.

All the earth doth worship thee; the Father everlasting.

To thee all Angels cry aloud! the Heavens and all the powers therein.

To thee Cherubin and Seraphin continually do cry,

Holy, holy, holy, Lord God of Sabaoth: Heaven and Earth are full of the majesty of thy glory.

### SONG. Mr. HARRISON. (Solomon.) *Dr. Boyce.*

    Softly rise, O southern breeze,
    And kindly fan the blooming trees;
    Upon my spicy garden blow,
    That sweets from ev'ry part may flow.

## CHORUS.

Ye southern breezes gently blow,
That sweets from ev'ry part may flow.

### CHORUS.   (Joseph.)   *Handel.*

O God, who in thy heav'nly hand
   Dost hold the hearts of mighty kings,
O take thy Jacob and his land
   Beneath the shadow of thy wings!
Thou know'st our wants before our pray'r,
   Then let us not confounded be;
Thy tender mercies let us share,
   O Lord, we trust alone in thee.

### DUET.   (Judas Macc.)   *Handel.*

See the conqu'ring hero comes,
Sound the trumpet, beat the drums;
Sports prepare, the laurel bring,
Songs of triumph to him sing.

See the godlike youth advance,
Breathe the flutes, and lead the dance;
Myrtle wreathes and roses twine,
To deck the hero's brow divine.

### FULL-CHORUS.

See the conqu'ring hero comes,
Sound the trumpet, beat the drums;
Sports prepare, the laurel bring,
Songs of triumph to him sing.

**CHORUS.     (Theodora.)          *Handel.***

Venus, laughing from the skies,
Will applaud her votaries:
When seizing the treasure,
We revel in pleasure,
And revenge sweet love supplies.

**SONG. Mrs. BILLINGTON. (Iphigenia.)** *Gluck.*

Donzelle semplici, no, non credete
A quelle lagrime che voi vedrete
Su gli occhi spargesi del traditor;

Più che son flebili i suoi sospiri;
Più par che s'agati, e che deliri,
Meno quel perfido commosso ha il cor.

Ah! per desendervi contro quell' Empio.
Donzelle semplici, vi sian d'esempio
E le mie smanie, e il mio rossor.

### SCENE from SAUL. *Handel.*

#### SINFONIA.

#### RECIT. Mrs. VAUGHAN.

Already see the daughters of the land
In joyful dance, with instruments of music,
Come to congratulate your victory.

#### SEMI-CHORUS.

Welcome, welcome, mighty king,
Welcome all who conquest bring;
Welcome DAVID, warlike boy,
Author of our present joy:
SAUL, who hast thy thousands slain,
Welcome to thy friends again:
DAVID his ten thousands slew,
Ten thousand praises are his due.

### RECIT. Mr. SALE.

What do I hear?—am I then sunk so low
To have this upstart boy preferr'd before me?

### FULL-CHORUS.

David his ten thousands slew,
Ten thousand praises are his due.

### CHORUS. (JUBILATE.) *Handel.*

Glory be to the Father, and to the son, and to the Holy Ghost.

As it was in the beginning, is now, and ever shall be, world without end. Amen.

**END OF THE SEVENTH CONCERT.**

(No. 8.)

UNDER THE DIRECTION OF

*The Earl of WILTON.*

# CONCERT OF ANTIENT MUSIC,
WEDNESDAY, MARCH 30, 1808.

## ACT I.

Overture. (*Sosarmes.*) *Handel.*
Motet. Qui pacem amatis. *Steffani.*
Quartet. and Chorus. Their sound. (*Messiah.*) *Handel.*
Recit. acc. Me, when the sun. ⎫
Song. Hide me from day's. ⎬ (*Il Pen.*) *Handel.*
Concerto 4th. Op. 5. *Martini.*
Recit. I feel the Deity. ⎫
Song. Arm, arm, ye brave. ⎬ (*Judas Macc.*) *Handel.*
Chorus. We come. ⎭
Chorus. For unto us. ⎫
Pastoral Symphony. ⎪
Recit. There were shepherds. ⎬ (*Messiah.*) *Handel.*
Chorus. Glory to God. ⎭

## ACT II.

Concerto 2nd. (*Grand*) *Handel.*
Chorus. He sent a thick. (*Is. in Egypt.*) *Handel.*
Cantata. See! from the silent grove. *Dr. Pepusch.*
Madrigal. As now the shades. *Dr. Cooke.*
Concerto 12th. *Corelli.*
Song. Praise the Lord. (*Esther.*) *Handel.*
Chorus. The depths. (*Israel in Egypt.*) *Handel.*

## ACT I.

#### TRIO. Mrs. VAUGHAN, Mess. HARRISON, and BARTLEMAN. *Steffani*.

Qui pacem amatis
Jam bella parate;
Pugnando certando,
Quietem sperate,

#### AIR. Mr. BARTLEMAN.

Nunquam erit in pace locus
O mortalis! nisi mundo
Devicto inferno superato;
Sparso nubium horrore,
Longe turbinum terrore;
Tunc ridebit solis fax
Si potentes debellati,
Cadent hostes profligati;
Tunc regnabit alme pax.

### AIR. Mrs. VAUGHAN.

Pax est munus bellatoris:
Contra hostes arma sonent,
Fremat ira, tela tonent,
Pradiat pax sinu furoris.

### CHORUS.

Qui pacem amatis,
Jam bella parate;
Pugnando, certando,
Quietem sperate.

### QUARTETTO.
#### Mrs. BILLINGTON, Messrs. Wm. KNYVETT, HARRISON, BARTLEMAN, and CHORUS.
(MESSIAH.) *Handel.*

Their sound is gone out into all lands, and their words unto the ends of the world.

### RECIT. acc. Mrs. BILLINGTON,
(IL PENSIEROSO.) *Handel.*

Me, when the Sun begins to fling
His flaring beams, me, goddess, bring

To arched walks of twilight groves,
And shadows brown, that Sylvan loves:
There, in close covert, by some brook,
Where no profaner eye may look.

### SONG.

Hide me from day's garish eye,
While the bee, with honey'd thigh,
Which at her flow'ry work doth sing,
And the waters murmuring,
With such concert as they keep,
Entice the dewy-feather'd sleep:
And let some strange mysterious dream
Wave at his wings, in airy stream
Of lively portraiture display'd,
Softly on my eye-lids laid.
Then, as I wake, sweet music breathe
Above, about, or underneath;
Sent by some spirit to mortals good,
Or the unseen genius of the wood.

### RECIT. Mr. BARTLEMAN.
(JUDAS MACC.) *Handel.*

I feel the Deity within,
Who, the bright cherubin between,

His radiant glory erst display'd;
   To Israel's distressful pray'r
   He hath vouchsaf'd a gracious ear,
And points out Macchabæus to their aid.
   Judah shall set the captive free,
   And lead us on to victory.

## SONG.

Arm, arm, ye brave; a noble cause,
The cause of Heaven your zeal demands!
  In defence of your nation, religion, and laws,
The Almighty Jehovah will strengthen your hands.

## CHORUS.

We come, we come, in bright array,
Judah, thy sceptre to obey!

---

## CHORUS.     (MESSIAH.)     *Handel.*

For unto us a Child is born, unto us a Son is given, and the government shall be upon his shoulder; and his name shall be called Wonderful, Counsellor, the Mighty God, the Everlasting Father, the Prince of Peace.

### RECIT. Mrs. BILLINGTON.

There were shepherds abiding in the field, keeping watch over their flock by night.

### RECIT. acc.

And, lo! the angel of the Lord came upon them, and the glory of the Lord shone round about them, and they were sore afraid.

### RECIT.

And the angel said unto them, Fear not, for, behold! I bring you good tidings of great joy, which shall be to all people; for unto you is born this day, in the city of David, a Saviour, which is Christ the Lord;

### RECIT. acc.

And suddenly there was with the angel a multitude of the heavenly host, praising God, and saying,

### CHORUS.

Glory to God in the highest, and peace on earth, good-will towards men!

END OF THE FIRST ACT.

## ACT II.

**CHORUS.** (Israel in Egypt.) *Handel.*

He sent a thick darkness over all the land, even darkness which might be felt.

He smote all the first-born of Egypt: the chief of all their strength.

But as for his people: he led them forth like sheep;

He brought them out with silver and gold: there was not one feeble person among their tribes.

**CANTATA.** Mr. HARRISON.
*Dr. Pepusch.*

### RECIT.

See! from the silent grove ALEXIS flies,
And seeks, with ev'ry pleasing art,
To ease the pain which lovely eyes
Created in his heart:

To shining theatres he now repairs,
  To learn CAMILLA's moving airs;
Where thus to MUSIC's power
  The swain address'd his pray'rs.

### AIR.

Charming sounds that sweetly languish!
MUSIC, O compose my anguish!
  Every passion yields to thee.

### RECIT.

APOLLO heard the foolish swain;
  He knew, when DAPHNE once he lov'd,
How weak, t'assuage an am'rous pain,
  His own harmonious art had prov'd,
And all his healing herbs how vain:
  Then thus he strikes the speaking strings,
  Preluding to his voice, and sings.

### AIR.

Sounds, tho' charming, can't relieve thee,
Do not, shepherd, then deceive thee,
  MUSIC is the voice of love.—
If the tender maid believe thee,
Soft relenting, kind consenting,
  Will alone thy pain remove.    *Da Capo.*

MADRIGAL.   Mrs. BILLINGTON,
Mess. HARRISON, Wm. KNYVETT, and
BARTLEMAN.   *Dr. Cooke.*

As now the shades of eve imbrown
　　The scenes where pensive poets rove,
From care remote, from envy's frown,
　　The joys of inward calm I prove.

What holy strains around me swell!
　　No wildly rude tumultuous sound;
They fix the soul in magic spell;
　　Soft let me tread this favour'd ground.

Sweet is the gale that breathes the spring,
　　Sweet thro' the vale yon winding stream;
Sweet are the notes love's warblers sing,
　　But sweeter friendship's solemn theme.

---

SONG.   Mrs. BILLINGTON. (ESTHER.) *Handel.*

　　Praise the Lord with cheerful noise,
　　　　Wake my glory, wake my lyre;
　　Praise the Lord, each mortal voice,
　　　　Praise the Lord, ye heavenly choir.
　　Zion now her head shall raise,
　　Tune your harps to songs of praise.   *Da Capo.*

CHORUS.    (ISRAEL IN EGYPT.)    *Handel.*

The depths have covered them; they sank into the bottom as a stone.

### CHORUS.

Thy right hand, O Lord, is become glorious in power: thy right hand, O Lord, hath dashed in pieces the enemy.

END OF THE EIGHTH CONCERT.

(No. 9.)

UNDER THE DIRECTION OF

## The Earl of DARTMOUTH.

# CONCERT OF ANTIENT MUSIC,

WEDNESDAY, APRIL 6, 1808.

### ACT I.

Overture.
Recit. acc. Comfort ye. ⎫
Song. Every valley. ⎬ (*Messiah.*) Handel.
Chorus. And the glory. ⎭
Quartet   Domine labia mia. *Vallotti.*
Concerto 7th. *Corelli.*
Recit.  Folle è Colui. ⎫
Song.   Nasce al bosco. ⎬ (*Ætius.*) Handel.
Chorus.   Cherub and Seraph.   (*Jephthah.*) Handel.
Song.   Sorprendermi vorresti. *Hasse.*
Chorus.   Great is Jehovah. ⎫
Trio and Chorus.   And with. ⎬ *Marcello.*

### ACT II.

Overture. (*Pastor Fido 2nd.*) Handel.
Chorus. Envy, eldest born. (*Saul.*) Handel.
Madrigal. Return my lovely maid. Dr. *Hutchinson.*
Motet. Spirto di Dio. *Lotti.*
Concerto 6th. (*From his Solos.*) *Geminiani.*
Recit.   When God is in his. ⎫
Song.    When storms. ⎬ (*Athalia.*) Handel.
Chorus.   O Judah, boast. ⎭
Song.   Se il ciel mi divide. (*Didone.*) *Piccini.*
Chorus.   Cum Sancto Spiritu. *Pergolesi.*

Q

## ACT I.

RECIT. acc. Mr. HARRISON.

COMFORT ye, comfort ye my people, saith your God; speak ye comfortably to Jerusalem; and cry unto her, that her warfare is accomplished, that her iniquity is pardoned.

The voice of him that crieth in the wilderness, Prepare ye the way of the Lord; make straight in the desert a highway for our God.

### SONG.

Every valley shall be exalted, and every mountain and hill made low; the crooked straight, and the rough places plain.

## CHORUS.

And the glory of the Lord shall be revealed, and all flesh shall see it together; for the mouth of the Lord hath spoken it.

QUARTET. Mrs. BILLINGTON, Messrs. HARRISON, Wm. KNYVETT, and BARTLEMAN. *Padre Vallotti.*

Domine labia mea aperies
Et os meum annunci abit laudentuam.

Quoniam si volius ses sacrificium
De dèssèm utique
Holocaustis non delectaberis.

RECIT. Mr. BARTLEMAN. (Ætius.) *Handel.*

Folle è Colui,
Che al tuo favor si fida
Instabile fortuno
Pur troppo o sorte infida,

## SONG.

Nasce al bosco in rozza cuna,
 Un felice pastorello
 E con l' aure di fortuna,
 Giunge i regni a dominar.
Presso al trono in regie fasce
 Sventurato un altro nasce,
 E fra l'ire della sorte,
 Va gli menti a pascolar. *Da Capo.*

---

### CHORUS. (JEPHTHAH.) *Handel.*

Cherub and seraphin, unbodied forms,
 The messengers of fate,
 His dread command await;
 Of swifter flight and subtler frame
 Than lightning's winged flame,
They ride on whirlwinds directing the storms.

---

### SONG. Mrs. BILLINGTON. *Hasse.*

 Sorprendermi vorresti
 Nume dell' alme imbelle;
 Ma in vono a me favelli,
 Nume non sei per me.

All' alma mia disciolta
In van catene appresti;
Fra suoi rigori involta
Scherno farà di te.

CHORUS. *Marcello.*

Great is Jehovah, and highly to be praised.

TRIO. Messrs. Wm. KNYVETT, HARRISON, and BARTLEMAN, and CHORUS.

And with songs I will celebrate the name of Jehovah most high.

END OF THE FIRST ACT.

## ACT II.

### CHORUS. (SAUL.) *Handel.*

Envy, eldest born of Hell!
Cease in human breast to dwell;
Ever at all good repining,
Still the happy undermining.
God and man by thee infested,
Thou by God and man detested;
Most thyself thou dost torment,
At once the crime and punishment.
Hide thee in the blackest night,
Virtue sickens at thy sight;
Hence, eldest born of Hell,
Cease in human breast to dwell.

MADRIGAL.  Mrs. BILLINGTON,
Mess. HARRISON, Wm. KNYVETT, and
BARTLEMAN.  *Dr. Hutchinson*

Return, return, my lovely maid;
   For summers pleasures pass away,
The trees' green liv'ries 'gin to fade,
   And Flora's treasures all decay.

No more at ev'ntide waileth sweet
   Sad Philomel the woods among;
Nor lark the rising morn doth greet:
   Return, my love, thou stay'st too long.

MOTET.               *Lotti.*
Solo Parts Mrs. VAUGHAN, Mess. HARRISON,
Wm. KNYVETT, and SALE, Jun.

Spirto di Dio, ch' essendo il mondo infante,
Tanto sull' onde il piè posar vi piacque;
Fate liete quest' acque,
Dove la nostra fè, più salda, e pura,
Di pietà, e di valor, con prove tante
Di secoli nel corso intatta dura.
Estendasi Regnante da mare a mar
La Veneta Fortuna,
Finch' eclisse fatal tolga la Luna.

RECIT. Mr. BARTLEMAN. (ATHALIA.) *Handel.*

When God is in his wrath reveal'd,
Where will the haughty lie conceal'd?

## SONG.

When Storms the proud to terrors doom,
   He forms the dark majestic scene,
He rolls the thunder thro' the gloom,
   And on the whirlwind rides serene.

## CHORUS.

O Judah, boast his matchless law,
   Pronounc'd with such tremendous awe;
When tempests his approach proclaim'd,
And Sinah's trembling mountain flam'd,
   And Judah then his terrors saw.

SONG. Mrs. BILLINGTON. (DIDONE.) *Piccini.*

Se il ciel mi divide
Dal cara mio sposo
Perchè non muccide
Pietoso il martir.

Divisa un momento
Dal dolce tesoro
Non vivo non moro
Ma prova il tormento.

D'un viva penoso
D'un l'ungo morir.

## CHORUS.

Cum Sancto Spiritu in gloria Dei patris.

**END OF THE NINTH CONCERT.**

(No. 10.)

UNDER THE DIRECTION OF

## The Earl FORTESCUE.

# CONCERT OF ANTIENT MUSIC,
### WEDNESDAY, APRIL 27, 1808.

### ACT I.

Overture. *(Atalanta.)* Handel.
Song. Tyrants would. ⎫
Chorus. Tyrants ye in vain. ⎭ *(Athalia.)* Handel.
Madrigal. Stay, Corydon. *Wilbye.*
Recit. Brethren and Friends. ⎫
Recit. acc. O! thou bright. ⎬ *(Joshua.)* Handel.
Chorus. Behold! the list'ning. ⎭
Concerto 2nd. *(From his Solos.)* Geminiani.
Scene from Saul. Wretch that I am. Handel.
Chorus. By slow degrees. *(Belshazzar.)* Handel.
Recit. acc. Ah! che pur. ⎫
Song. Dove il mio. ⎭ *(Astianatte.)* Jomelli.
Chorus. The glorious company. *(Te Deum.)* Handel.

### ACT II.

Overture. *(Ariadne.)* Handel.
Psalm 18th. *(St. Matthew's Tune.)* Dr. Croft.
Song. Non so donde. Bach.
Anthem. Hosanna to the Son of David. *Orlando Gibbons.*
Recit. My cup is full. ⎫
Song. Shall I in Mamre's. ⎬ *(Joshua.)* Handel.
Chorus. For all these mercies. ⎭
Cantata. Mad Bess. Purcell.
Concerto 5th. Corelli.
Madrigal. Let me careless. Linley.
Chorus. Immortal Lord. *(Deborah.)* Handel.

## ACT I.

SONG. Mrs. VAUGHAN. (ATHALIA.) *Handel.*

    Tyrants would, in impious throngs,
    Silence his adorer's songs;
    But shall Salem's lyre and lute
    At their proud commands be mute.

### CHORUS.

    Tyrants, ye in vain conspire;
    Wake the lute, and strike the lyre.
    Why should Salem's lyre and lute
    At their proud commands be mute?

### MADRIGAL. *Wilbye.*

Stay, Corydon, thou swain, talk not so soon of dying,
What tho' thy heart be slain, what tho' thy love be
    flying;

She threatens thee but dares not strike,
Thy nymph is light and shadow like;
For if thou follow her she'll fly from thee,
But if thou fly from her she'll follow thee.

### RECIT. Mr. HARRISON. (JOSHUA.) *Handel.*

Brethren and friends, what joy this day imparts,
To meet such brave, such firm, united hearts!
What tho' the tyrants, an unnumber'd host,
Their strength in horse, and iron chariots boast!
Now shines the sun, that fixeth Canaan's doom!
Trust in the Lord, and ye shall overcome!

### RECIT. acc.

O! thou bright Orb, great ruler of the day!
Stop thy swift course, and over Gibeon stay;
And oh! thou milder lamp of light, the Moon,
Stand still, prolong thy beams in Ajalon.

### CHORUS.

Behold! the list'ning Sun the voice obeys,
And in mid heaven his rapid motion stays!
Before our arms the scatter'd nations fly;
Breathless they pant, they yield, they fall, they die.

## SCENE FROM SAUL. *Handel.*

### RECIT. Mr. BARTLEMAN.

*Saul.* Wretch that I am! of my own ruin author!
Where are my old supports? The valiant youth,
Whose very name was terror to my foes,
My rage has drove away. Of God forsaken,
In vain I ask his counsel! he vouchsafes
No answer to the sons of disobedience!
Ev'n my own courage fails me!—Can it be?
Is Saul become a coward?—I'll not believe it!
If heav'n denies thee aid, seek it from hell!

### RECIT.

'Tis said here lives a woman, close familiar
With the enemy of mankind: her I'll consult,
And know the worst. Her art is death by law;
And while I minded law, sure death attended
Such horrid practices: Yet, O hard fate!
Myself am now reduc'd to ask the counsel,
Of those I once abhorr'd!

### RECIT. Mrs. BILLINGTON.

*Witch.* With me what would'st thou?

*Saul.* I wou'd, that by thy art thou bring me up
The man whom I shall name.

*Witch.*               Alas! thou know'st
How Saul has cut off those who use this art.
Would'st thou ensnare me?

*Saul.*               As Jehovah lives,
On this account no mischief shall befal thee.

*Witch.* Whom shall I bring up to thee?

*Saul.* Bring up Samuel.

## AIR.

*Witch.* Infernal spirits, by whose pow'r
    Departed Ghosts in living forms appear,
Add horror to the midnight hour,
    And chill the boldest hearts with fear:
        To this stranger's wond'ring eyes
    Let the prophet Samuel rise.

## RECIT. acc. Mr. BELLAMY.

*Sam.* Why hast thou forc'd me from the realms of peace
Back to this world of woe?

*Saul.*              O holy prophet!
Refuse me not thy aid in this distress.
The num'rous foe stands ready for the battle:
God has forsaken me: No more he answers
By prophets or by dreams: No hope remains,
Unless I learn of thee what course to take.

*Sam.* Hath God forsaken thee? And dost thou ask
My counsel? Did I not foretel thy fate,
When, madly disobedient, thou didst spare
The curst Amalekite, and on the spoil
Didst fly rapacious? Therefore God this day
Hath verified my words in thy destruction;
Hath rent the kingdom from thee, and bestow'd it
On David, whom thou hatest for his virtue.
Thou and thy sons shall be with me to-morrow,
And Israel by Philistine arms shall fall.
The Lord hath said it: he will make it good.

## CHORUS. (BELSHAZZAR.) *Handel.*

By slow degrees the wrath of God to its meridian height ascends;
There mercy long the dreadful bolt suspends,
　　Ere it offending man annoy:
Long patient, for repentance waits; reluctant to destroy.
　At length the wretch obdurate grown,
　Infatuate, makes the ruin all his own;
　And ev'ry step he takes, on his devoted head
　Precipitates the thunder down.

RECIT. acc.   Mrs. BILLINGTON.

(ASTIANATTE.)            *Jomelli.*

Ah! che pur troppo è ver
Al nascer mio qual mai,
Splendeva in Cielo astro funesto.
Qual rio momento è questo?
Dal trono di Micene
In orrida prigion,
Dal serto, ai ceppi
M'accoglieva la Reggia
Sposo d'Ermione.
Or queste oscure soglia
Mi racchiudon qual reo,
Dunque perchè animoso,
Una publica injiùria
Una privata offesa vendicai.
Non rivedrò più mai
La mia diletta sposa.
O sorte iniqua! O sempre
A me avverso destin!
E l'aure infeste,
Tu spiri ancora
O sventurato Oreste.

### SONG.

Dove il mio guardo giro;
Con torva, orribil faccia
Furia crudel minaccia
E mi empie di terror.

Misero! io già nel cor,
La sento incrudelir.
Chi sa dove mi guida
Colla sua scorta infida,
Finisser le mei pene,
Almeno col morir. *Da Capo.*

CHORUS. (Dettingen te Deum.) *Handel.*

The glorious company of the Apostles praise thee.
The goodly fellowship of the Prophets praise thee.
The noble army of martyrs praise thee.

### CHORUS.

The holy Church throughout all the world doth acknowledge thee the Father of an infinite Majesty.

### CHORUS.

Thine honourable, true, and only Son; also the Holy Ghost the Comforter.

### AIR. Mr. BELLAMY, and CHORUS.

Thou art the King of Glory, O Christ! Thou art the everlasting Son of the Father.

END OF THE FIRST ACT.

## ACT II.

PSALM XVIII. (St. Matthew's Tune.) *Dr. Croft*

O God my strength and fortitude, of force I must love thee;
Thou art my castle and defence, in my necessity:
My God, my rock, in whom I trust, the worker of my wealth,
My refuge, buckler, and my shield, the horn of all my health.

When I sing laud unto the Lord, most worthy to be serv'd;
Then from my foes I am right sure, that I shall be preserv'd.
The pangs of death did compass me, and bound me ev'ry where;
The flowing waves of wickedness did put me in great fear.

The Lord descended from above, and bow'd the heav'ns high,
And underneath his feet he cast, the darkness of the sky;
On cherub and on cherubin, full royally he rode,
And on the wings of mighty winds, came flying all abroad.

### SONG. Mr. HARRISON. *Bach.*

Non so d'onde viene
Quel tenero affetto,
Quel moto, che ignoto
Mi nasce nel petto;
Quel gel, che le vene
Scorrendo mi và.
Sono a destarmi
Sì fiera contrasti,
Non parmi che basti
La sola pietà. *Da Capo.*

### ANTHEM. *Orlando Gibbons.*

Hosanna to the Son of David
Blessed is he that cometh in the name of the Lord!
Blessed be the King of Israel!
Peace in Heav'n, and glory in the highest places!
Hosanna in the highest Heav'ns!

RECIT.    Mr. BARTLEMAN. (JOSHUA.)    *Handel.*

My cup is full, how blest in this decree:
How can my thanks suffice, the Lord and Thee!

### SONG.

Shall I in Mamre's fertile plain,
The remnant of my days remain?
And is it giv'n to me to have
A place with Abraham in the grave?
For all these mercies I will sing,
Eternal praise to Heav'n's high King.

### CHORUS.

For all these mercies we will sing,
Eternal praise to Heav'n's high King.

CANTATA.    Mrs. BILLINGTON,    *Purcell.*
MAD BESS.

From silent shades and the Elysium groves,
Where sad departed spirits mourn their loves,
From crystal streams, and from that country where
Jove crowns the fields with flowers all the year,
Poor senseless Bess, cloath'd in her rags and folly,
Is come to cure her love-sick Melancholy.

Bright Cynthia kept her revels late,
    While Mab the Fairy Queen did dance,
And Oberon did sit in state,
    When Mars at Venus ran his lance.

In yonder cowslip lies my dear,
    Entomb'd in liquid gems of dew,
Each day I'll water it with a tear,
    Its fading blossom to renew.

For since my love is dead, and all my joys are gone,
    Poor Bess for his sake,
    A garland will make,
My music shall be a groan.

    I'll lay me down and die
    Within some hollow tree,
      The raven and cat,
      The owl and bat,
    Shall warble forth my elegy.

Did you not see my Love as he pass'd by you?
His two flaming eyes, if he come nigh you,
They will scorch up your hearts.—Ladies, beware ye,
Lest he should dart a glance that may ensnare ye.

    Hark! hark! I hear old Charon bawl,
      His boat he will no longer stay.
    The furies lash their whips, and call,
      Come away, come away!

Poor Bess will return to the place whence she came,
   Since the world is so mad she can hope for no cure,
For Love's grown a bubble, a shadow, a name,
   Which fools do admire and wise men endure.

    Cold and hungry am I grown,
    Ambrosia will I feed upon,
      Drink nectar still and sing;
    Who is content
    Does all sorrow prevent,
    And Bess in her straw,
    Whilst free from the law,
      In her thoughts is as great as a King!

## MADRIGAL. Mrs. BILLINGTON, Mess. HARRISON, W. KNYVETT, SALE, and BARTLEMAN. *T. Linley.*

Let me careless, and unthoughtful lying,
  Hear the soft winds above me flying,
    With all the wanton boughs dispute;
    And the more tuneful birds replying;
  Till my DELIA with her heav'nly song
Silence the wanton boughs, and birds that sing among.

## CHORUS.  (Deborah.)  *Handel.*

Immortal Lord of earth and skies,
Whose wonders all around us rise;
Whose anger, when it awful glows,
To swift perdition dooms thy foes:
O grant a leader to our host,
Whose name with honour we may boast;
Whose conduct may our cause maintain,
And break our proud oppressors' chain!

END OF THE TENTH CONCERT.

(No. 11.)

UNDER THE DIRECTION OF

## The Earl of DARNLEY.

# CONCERT OF ANTIENT MUSIC,
### WEDNESDAY, MAY 4, 1808.

### ACT I.

Overture, with Ad. Movement. *(Berenice.)* — *Handel.*
Chorus. Flush'd with conquest. *(Alex. Balus.)*
Recit. The praise of Bacchus.
Song. Bacchus, ever fair. *(Alex. Feast.)*
Chorus. Bacchus' blessings.
Song and Cho. Populous cities.
Recit. But let my due feet. *(L'Allegro.)*
Chorus. Then let the pealing.
Song and Cho. These pleasures.
Concerto. *(Select Harmony.)*
Duet. The Lord is. *(Israel in Egypt.)*
Song. Dove sei amato bene. *(Rodelinda.)*
Anthem. The King shall rejoice.

### ACT II.

| | |
|---|---|
| Overture 5th. Op. 8. | *Martini.* |
| Song. A morir se mi condanna. | *De Majo.* |
| Glee. Gently touch the warbling. | *Geminiani.* |
| Frost Scene. *(King Arthur.)* | *Purcell.* |
| Chorus. Gloria in excelsis. | *Pergolesi.* |
| Canzonet. I, my dear. | *Travers.* |
| Concerto 9th. | *Geminiani Corelli.* |
| Madrigal. Since first I saw your face. | *Ford.* |
| Cantata. From rosy bow'rs. | *Purcell.* |
| Chorus. Gloria in excelsis. | *Negri.* |

## ACT I.

### CHORUS. (ALEX. BALUS.) *Handel.*

Flush'd with conquest, fir'd by Mithra,
　Fountain of eternal rays,
Sing we to Balus, sing we to Mithra,
　Songs of triumph, songs of praise.

### RECIT. Mr. HARRISON. (ALEX. FEAST.) *Handel.*

The praise of Bacchus, then, the sweet musician sung,
　Of Bacchus, ever fair, and young:
　　The jolly god in triumph comes;
　　Soud the trumpets, beat the drums:

Flush'd with a purple grace,
He shews his honest face;
Now give the hautboys breath; he comes! he comes!

### SONG.　Mr. BELLAMY.

Bacchus, ever fair and young,
Drinking joys did first ordain;
Bacchus' blessings are a treasure,
Drinking is the soldier's pleasure;
Sweet is pleasure after pain.

### CHORUS.

Bacchus' blessings are a treasure,
Drinking is the soldier's pleasure;
Rich the treasure,
Sweet the pleasure,
Sweet is pleasure after pain.

### SONG.　Mr. J. B. SALE.
#### (L'Allegro.)

Populous cities please me then,
And the busy hum of men.

## CHORUS.

Populous cities please us then,
And the busy hum of men;
Where throngs of knights and barons bold,
In weeds of peace high triumphs hold;
With store of ladies, whose bright eyes
Rain influence, and judge the prize
Of wit, or arms; while both contend
To win her grace whom all commend.  *Da Capo.*

## RECIT. Mrs. BILLINGTON.
### (IL PEN.)

But let my due feet never fail
To walk the studious cloister's pale;
And love the high embowed roof,
With antique pillars massy proof:
And story'd windows richly dight,
Casting a dim religious light.

## CHORUS.

There let the pealing organ blow
To the full-voic'd choir below,
In service high and anthem clear,

### SOLO.

As may with sweetness through mine ear,
Dissolve me into extacies,
And bring all heav'n before mine eyes.

### SONG. Mrs. BILLINGTON.

These pleasures, Melancholy give,
And I with thee will chuse to live.

### CHORUS.

These pleasures, Melancholy give,
And we with thee will chuse to live.

### DUET. Mr. BARTLEMAN & Mr. BELLAMY.
(Israel in Egypt.)

The Lord is a man of war, Lord is his name, Pharaoh's chariots and his host hath he cast into the sea; his chosen captains also are drowned in the Red Sea.

## SONG. Mrs. BILLINGTON.
### (Rodelinda.)

Dove sei, amato bene?
Vieni l'alma a consolar.
Son oppressa da tormenti,
Ed i crudi miei lamenti,
Sol con te posso bear. *Da Capo.*

## ANTHEM. *Handel.*

The King shall rejoice in thy strength, O Lord; exceeding glad shall he be in thy salvation.

Glory and great worship shalt thou lay upon him; thou hast prevented him with the blessings of goodness, and hast set a crown of pure gold upon his head.

### HALLELUJAH.

END OF THE FIRST ACT.

## ACT II.

SONG.   Mr. HARRISON.        *De Majo.*

A morir se mi condanna,
La tiranna ingrata sorte;
Ah! si cada almen da forte,
Senza' un ombra di viltà.

GLEE.            *Geminiani.*
*Harmonised by Dr. Hayes.*
Mrs. BILLINGTON, Mrs. VAUGHAN,
Mr. HARRISON, and Mr. BARTLEMAN.

Gently touch the warbling lyre,
   Chloe seems inclin'd to rest;
Fill her soul with fond desire,
   Softest notes will soothe her breast;
Pleasing dreams assist in love,
Let them all propitious prove.

FROST SCENE.   (KING ARTHUR.)   *Purcell.*

### CUPID.   Mrs. VAUGHAN.

What ho! thou Genius of this Isle! what ho!
Ly'st thou asleep beneath those hills of snow?
What ho! stretch out thy lazy limbs; awake;
And winter from thy furry mantle shake.

### COLD GENIUS.   Mr. BARTLEMAN.

What power art thou, who from below
Hast made me rise, unwillingly and slow,
From beds of everlasting snow?
See'st thou how stiff, and wond'rous old,
Far, far unfit to bear the bitter cold?
I can scarcely move, or draw my breath;
Let me freeze again to death.

### CUPID.

Thou doating fool, forbear, forbear,
What! dost thou dream of freezing here?
   At Love's appearing,
   All the sky clearing,
The stormy winds their fury spare.
Thou doating fool, forbear, forbear,
What! dost thou dream of freezing here?

Winter subduing,
    Spring renewing,
My beams create a more glorious spring,
Thou doating fool, forbear, forbear,
What! dost thou dream of freezing here?

### COLD GENIUS.

Great Love! I know thee now!
Eldest of the Gods art thou!
Heaven and Earth by thee were made;
    Human nature
    Is thy creature,
Every where art thou obey'd.

### CUPID.

'Tis I that have warm'd you:
In spite of cold weather,
I've brought you together;
'Tis I that have warm'd you.

### CHORUS.

'Tis Love that has warm'd us:
In spite of cold weather,
He brought us together:
'Tis Love that has warm'd us.

## CHORUS. *Pergolesi.*

Gloria in excelsis; Deo gloria
Et in terra pax.
Hominibus bonæ voluntatis.

## CANZONET.

Mess. HARRISON and BARTLEMAN. *Travers.*

I, my dear, was born to-day,
So all my jolly comrades say;
They bring me music, wreaths and mirth,
And ask to celebrate my birth.

Little, alas! my comrades know,
That I was born to pain and woe;
To thy denial, to thy scorn,
Better I had ne'er been born:
I wish to die, ev'n whilst I say,
I, my dear, was born to-day.

I, my dear, was born to-day,
Shall I salute the rising ray?
Well-spring of all my joy and woe,
Clotilda, thou alone dost know.

Shall the wreath surround my hair,
Or shall the music please my ear?
Shall I, my comrades' mirth receive,
And bless my birth, and wish to live?

Then let me see great Venus chase,
Imperious anger from thy face:
Then let me hear thee smiling say,
Thou, my dear, wert born to-day.

---

MADRIGAL. Mrs. BILLINGTON,
Mess. HARRISON, W. KNYVETT, and SALE.
*Ford.*

Since first I saw your face, I resolv'd
   To honour and renown you;
If now I be disdain'd, I wish
   My heart had never known you.
What! I that lov'd, and you that lik'd,
   Shall we begin to wrangle?
No, no, no, no! my heart is fast,
   And cannot disentangle.

---

CANTATA.     Mrs. BILLINGTON,     *Purcell.*
   RECIT.

From rosy bow'rs where sleeps the god of love,
   Hither ye little waiting Cupids fly;
Teach me in soft melodious songs to move
   With tender passion my heart's darling joy.
Ah! let the soul of music tune my voice
   To win dear Strephon who my soul enjoys.

## AIR.

Or if more influencing is to be brisk and airy,
    With a step and a bound,
    And a frisk from the ground,
I will trip like any fairy.
As once on Ida dancing were three celestial bodies,
    With an air and a face,
    And a shape and a grace
I will charm like Beauty's goddess.

## RECIT.

    Ah! 'tis all in vain,
  Death and despair must end the fatal pain.
  Cold despair disguis'd like snow, and rain
  Falls on my breast; bleak winds in tempests blow,
My veins all shiver, and my fingers glow;
My pulse beats a dead march for lost repose,
And to a solid lump of ice my poor fond heart is froze.

## AIR.

  Or say, ye pow'rs, my peace to crown,
    Shall I thaw myself, or drown?
Amongst the foaming billows,
    Increasing all with tears I shed,
On beds of ooze and crystal pillows,
    Lay down my love-sick head.

No, I'll straight run mad,
   That soon my heart will warm:
When once the sense is fled,
   Love has no pow'r to charm,
Wild thro' the woods I'll fly,
   Robes, locks shall thus be tore;
A thousand deaths I'll die,
   E'er thus in vain adore.

## CHORUS. *Negri.*

Gloria in excelsis; Deo gloria
Et in terra pax.
Hominibus bonæ voluntatis.

**END OF THE ELEVENTH CONCERT.**

(No. 12.)

UNDER THE DIRECTION OF

## The Earl of WILTON.

# CONCERT OF ANTIENT MUSIC,
### WEDNESDAY, MAY 11, 1808.

### ACT I.

Overture and Dead March. \} (*Saul.*)    *Handel.*
Chorus. How excellent.
Cantata. When winds breathe soft.    *Webbe.*
Concerto 2nd.    (Op. 8.)    *Martini.*
Duet. Saldi marmi.    *Steffani.*
Chorus and Semi-Chorus. \} (*Messiah.*)    *Handel.*
   Lift up your heads.
Duet. O never bow. \} (*Jud. Macc.*) *Handel.*
Chorus. We never will bow.

### ACT II.

Concerto 8th.    *Corelli.*
Song. Pleasure, my former. (*Time & Truth.*) *Handel.*
Quintett. Doni pace.    (*Flavius.*)    *Handel.*
Concerto 11th.    (Grand.)    *Handel.*
Recit. when he is in. \}
Song. When storms the proud. (*Athalia.*) *Handel.*
Chorus. O Judah, boast.
Song. Ombre! larve!    (*Alceste.*)    *Gluck.*
Anthem. My heart is inditing.    *Handel.*

X

## ACT I.

### CHORUS. *Handel.*

How excellent thy name, O Lord!
 In all the world is known!
Above all heavens, O King ador'd,
 How hast thou set thy glorious throne!

### AIR. Mrs. VAUGHAN.

An infant rais'd by thy command,
 To quell thy rebel foes,
Could fierce Goliath's dreadful hand
 Superior in the fight oppose.

### TRIO-CHORUS.

Along the monster Atheist strode,
  With more than human pride!
And armies of the living God,
  Exulting in his strength defy'd.

### SEMI-CHORUS.

The youth inspir'd by thee, O Lord!
  With ease the boaster slew;
Our fainting courage soon restor'd,
  And headlong drove that impious crew.

### CHORUS.

How excellent thy name, O Lord!
  In all the world is known!
Above all heavens, O King ador'd,
  How hast thou set thy glorious throne!
                                HALLELUJAH.

### CANTATA.
Mrs. BILLINGTON, Mess. W. KNYVETT,
  HARRISON, ELLIOTT, and SALE. *Webbe.*

When winds breathe soft along the silent deep,
The waters curl, the peaceful billows sleep,

A stronger gale the troubled wave awakes,
The surface roughens, and the ocean shakes!
More dreadful still, when furious storms arise,
The mountain billows bellow to the skies;
On liquid rocks the tott'ring vessel's tost,
Unnumber'd surges lash the foaming coast;
The raging waves excited by the blast,
Whiten with wrath, and split the sturdy mast.
When in an instant, He who rules the floods,
Earth, air, and fire, JEHOVAH, GOD of GODS,
In pleasing accents speaks his sovereign will,
And bids the waters and the winds be still.
Hush'd are the winds, the waters cease to roar,
Safe are the seas, and silent as the shore.
Now say, what joy elates the sailors's breast,
With prosp'rous gales so unexpected blest;
What ease, what transport, in each face is seen!
The heavens look bright! the air and sea serene!
For ev'ry plaint, we hear a joyful strain
To HIM, whose pow'r unbounded rules the main.

DUET. Mrs. BILLINGTON & Mr. HARRISON.
*Steffani.*

    Saldi marmi che coprite
    Del mio ben l'ignuda salma
    Ch'ogni dì, più in mezz'all'alma
    La mia fede stabilite,
    Che ne dite?
    Deggio al nuovo desire
    Opporre il vostro gelo
    O pur morire?

## RECIT. Mrs. BILLINGTON.

Così Fille dicea,
Del suo perduto bene ;
Rivolta un giorno
Alle bellezze estinte.
Vissela di Fileno
Lunga stagione
In fortunati amori :
Ma già le bionde ariste
Quattro volte divise
Avea del suolo
Del curvo mietitor
La falce adunca ;
Da ch' ei scendendo a morte
Tra solitarj ardor
Lasaciolla in vit.
Non vantar mai tra tanto,
Lacci un crin,
Risi un labro,
O strali un ciglio
Onde il suo cor fedele
O piagato, o invaghito,
O avvinto fosse.
Mostrolle al fine il caso
Ne' begl' occhi di Tirsi
Del amato Filen
Mille sembianze :
Onde fatta incapace
Di resis'er al bel
Cn' amò una volta ;

Risoluta d'amare
Ancora un dì;
Parlando a pensier suoi,
Disse così.

## DUET.

Incostanza! e che pretendi?
Amerò, si, ch'amerò.
So ben io come si può
Cangiar amanti.
    E non cangiar gl' incendi.

---

### CHORUS.     (MESSIAH.)     *Handel.*

Lift up your heads, O ye gates, and be ye lift up ye everlasting doors, and the King of Glory shall come in.

### SEMI-CHORUS.

Who is the King of Glory?

### SEMI-CHORUS.

The Lord, strong and mighty, the Lord mighty in battle.

### SEMI-CHORUS.

Lift up your heads, O ye gates, and be ye lift up ye everlasting doors, and the King of Glory shall come in.

### SEMI-CHORUS.

Who is the King of Glory?

### SEMI-CHORUS.

The Lord of Hosts, he is the King of Glory.

### FULL-CHORUS.

The Lord of Hosts, he is the King of Glory.

---

DUET. Mrs. BILLINGTON, & Mr. HARRISON.
(JUDAS MACC.) *Handel.*

O never, never bow we down
To the rude stock, or sculptur'd stone;
But ever worship Israel's God,
Ever obedient to his awful nod.

## CHORUS.

We never, never will bow down
To the rude stock, or sculptur'd stone—
We worship God, and God alone.

END OF THE FIRST ACT.

## ACT II.

### SONG.  Mr. HARRISON.
#### (TIME AND TRUTH.) *Handel.*

Pleasure, my former ways resigning,
To Virtue's cause inclining,
   Thee, Pleasure, now I leave:
Lest when my spirits fail me,
Repentance can't avail me,
   Nor in sickness comfort give.   *Da Capo.*

### QUINTETTO.
Mrs. BILLINGTON, Mrs. VAUGHAN,
Mess. HARRISON, W. KNYVETT, and SALE.
#### (FLAVIUS.) *Handel.*

Doni Pace ad ogni core
Quella gioia che sparì
E cessato or il dolore
Goda ogn' alma in questodì.   *Da Capo.*

RECIT. Mr. BELLAMY. (ATHALIA.) *Handel.*

When he is in his wrath reveal'd,
Where shall the haughty lie conceal'd?

### SONG.

When storms the proud to terrors doom'd,
   He forms the dark majestic scene,
He rolls the thunder thro' the gloom,
   And on the whirlwind rides serene.

### CHORUS.

O Judah boast his matchless law,
Pronounc'd with such tremendous awe,
When tempests his approach proclaim'd,
And inah's trembling mountain flam'd;
All Judah then his terrors saw.

SONG. Mrs. BILLINGTON. (ALCESTE.) *Gluck.*

Ombre! Larve! compagne di morte
Non vi chiedo, non voglio pietà;
Se vi tolgo l'amato consorte
Abbandono una sposa fedel:
Non mi lagno di questo mia sorte,
Questo cambio non chiamo crudel.

Ombre! Larve! compagne di morte
Non v'offenda sì guista pietà.
Forza ignota che in petto mi sento
M'avvalora, mi sprona al cimento,
Di me stessa pi più grande mi fa. *Da Capo.*

## ANTHEM. *Handel.*

My heart is inditing of a good matter; I speak of the things which I have made unto the king.

Kings daughters were among their honourable women.

Upon thy right hand did stand the queen in vesture of gold; and the king shall have pleasure in thy beauty.

Kings shall be thy nursing fathers, and queens thy nursing mothers.

END OF THE TWELFTH CONCERT.

Printed by Amazon Italia Logistica S.r.l.
Torrazza Piemonte (TO), Italy